First Steps in

# DIGITAL DESIGN

A RotoVision Book

Published and distributed by RotoVision SA
Route Suisse 9
CH-1295 Mies
Switzerland

RotoVision SA
Sales and Editorial Office
Sheridan House, 114 Western Road
Hove BN3 1DD, UK

Tel: +44 (0)1273 72 72 68
Fax: +44 (0)1273 72 72 69
www.rotovision.com

10 9 8 7 6 5 4 3 2 1

ISBN: 2-940361-11-8

Contributing Editor/Project Manager: Chris Middleton
Art Director: Tony Seddon
Design: Studio Ink

Reprographics in Singapore
by ProVision Pte. Ltd.
Tel: +65 6334 7720
Fax: +65 6334 7721

Printed in China by Midas Printing International Ltd.

First Steps in

# DIGITAL DESIGN

USE YOUR COMPUTER TO CREATE GREAT

- Letterheads and logos
- Invitations and cards
- Brochures and flyers
- Web sites and multimedia

**David Dabner** *design principles*

**Luke Herriott** *projects*

RotoVision

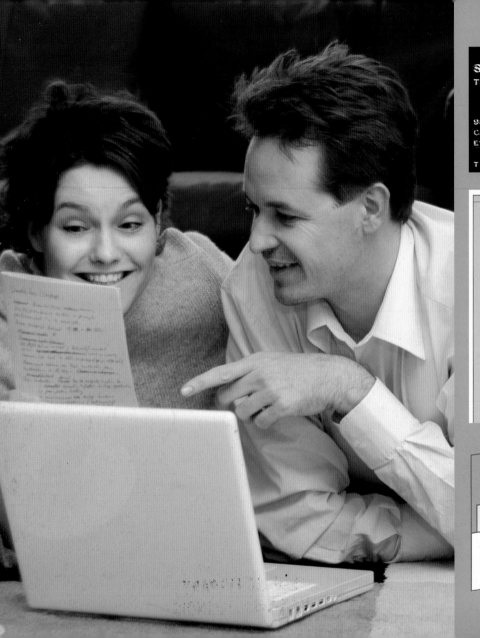
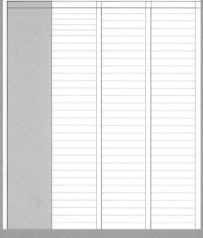

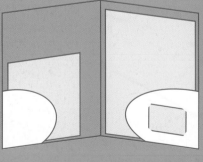

# Introduction

## DESIGN IS ALL AROUND US

Our money is on this poster having grabbed your attention straight away: it demands you look at it, but it also communicates a message in a clever and appropriate way. This charity "red nose day" is all about using comedy to raise money for vulnerable children.

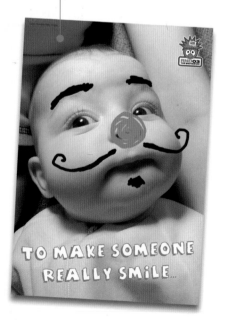

TO MAKE SOMEONE REALLY SMILE...

**Good design is all around us, but there is just as much bad design out there competing for our attention. Good design is often seen as something exclusive, but the reality is that it is essential to get your message across.**

Sitting in your home is the means to create professional-looking graphic designs and publications—your household computer.

This book will show you some of the basic, non-technical principles of graphic design —including layouts, typography, and materials—and then explain how to make your computer the creative hub of dozens of design projects for you, your home business, your community, or simply for your friends and family.

With digital technology, there is no longer any barrier to creating at home whatever type of design you want—a CD or DVD cover, logos, business cards, a Web site, or even a magazine or newsletter for your local community… the only limits are those of your imagination.

We're surrounded by design every day, and make decisions based on it, often without realizing. Can't read the typeface on that Web site? Move on somewhere else, there's no time to waste! Don't like the look of this company's logo, catalog, or advertisement? You won't be shopping there! People will make these same decisions about you, based on your designs. Bad design is a barrier to getting your message across.

Let's say you've set up a home business. If people don't like the look of your message, they won't read it; if your message is "experienced and professional" but the design says "cartoon graphics" then you will never reach your intended audience.

Computers also open the door to a seemingly infinite variety of creative resources, from free typefaces to free graphics and photos.

The result? It's easy to get pulled into the never-ending online rush hour and throw a design together without giving it a second thought. Don't do it! Your software is in on the act as well, and probably includes dozens of templates that you can apply without thinking. Such tools are a bonus, and save valuable time, but there is no better template than learning some basic techniques.

The fact is, there's nothing mysterious about good design; it's just a matter of learning a few basic rules and then applying them in your work. Just as every building around us has an underlying structure that supports it, so does every newspaper, magazine, and advertisement that you might read (or decide not to). Those techniques are easy to master, and even easier to apply—and this book will show you how.

The first secret is: get inspired by designs in the world around you. Good design not only tells you what a product or project is, it also tells you what it is like, what it is about—and who it is for. Although your own ambitions might be on a modest or local scale, the decisions you make in your design work today will influence how people think about you and your venture tomorrow.

Now let's get creative!

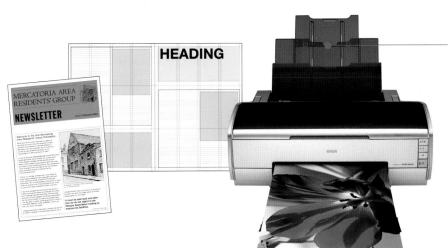

**FROM CONCEPT TO FINISHED PROJECT**
Turn to page 126 to find out how to transform the bare bones of this newsletter project into a colorful, eye-catching product that will fly out of your printer and into people's mailboxes to spread the word.

# What do you need?

**The vital tool is your imagination, coupled with a willingness to learn some basic techniques. Once you've got the general idea, there'll be nothing stopping you going far beyond the limits of this book.**

The next vital tool is your computer, which almost certainly comes with a range of basic text- and image-editing and painting tools preinstalled. Either a standard, Windows-based PC or an Apple Mac computer will suffice. Some of the projects can be done using just a wordprocessing program, such as Microsoft Word.

If you have an Apple Mac, then you have bought yourself a computer that is designed to be at the center of a range of lifestyle devices and creativity. However, you will need to buy Mac-compatible software and peripherals (such as printers), while software downloads may be harder to come by.

If you have purchased a PC, you're part of the 90% global majority, which means loads of

**APPLE MACS**
Apple's Mac computers, like this iMac G5, are a stable platform for design, but are usually more expensive than PCs.

available software, compatible devices, and downloadable tools—but a platform that is perhaps not quite so well designed as Apple's for creative work.

Consider buying good image-editing software. One option is Adobe Photoshop Elements (the consumer version of the professional Photoshop software package), and another is Paintshop Pro. Find out what's available locally, or online, as there are plenty of other options. If you don't have either, then use what comes preinstalled and push it to the limit to find out what it can do. Upgrading to a dedicated software package will give you the potential to get much more creative.

**PCS**
PCs are usually less expensive than Macs and more software tends to be available for them, but many people find them a less satisfying platform for graphics.

A drawing or illustration program will also be handy, but it's not essential. If you have a page-layout design program, then you truly have everything you need, but again, it's not a vital thing to have.

A digital camera—whether it is a professional one or a compact model—is a great way of creating source material for truly innovative graphics. Software such as Photoshop Elements includes a variety of filters and effects for turning photographic imagery into creative graphic effects that you can incorporate into logos, letterheads, and other graphic designs. For example, shoot a self-portrait, and use your software to turn it into a watercolor-style illustration to use on a CV, or your personal letterhead!

A scanner is another invaluable tool to have at your disposal; you may have been given one with your PC, or you might have one built into your desktop printer. If not, shop around and buy one, as they are usually inexpensive.

Few of the projects have instructions that are specific to any one piece of software: you'll find that all of the projects are fun, general, helpful, and creative, rather than technical. This isn't a software manual!

We hope you enjoy taking your first steps in digital design.

SCANNERS
Scan photos, drawings, objects, and textures and import them into your designs for added effect.

# Principles of good design

**CREATIVE DESIGN STYLES**
Even loose, modern designs have a solid underlying structure that gives the layout a logic and stability.

**GRIDS**
Most publications, including this book, are based on an invisible grid.

**There have never been more opportunities to get creative with graphic design. Whether you are doing it for fun on your own or with a family group, or whether you run a small business at home, the PC and Apple Mac computers, low-cost digital photography, and desktop scanners have put the whole world of design at your fingertips.**

So what are the principles of good design? It's simple to say it, but it should be attractive, easy to read, and give a good general idea of what the message is—and that message might be a literal one, or an emotion, a mood, perhaps even a set of values.

Such things do not happen by chance; having some design or image-editing software doesn't mean you will be able to churn out good design by simply hitting a button or clicking your mouse.

Before looking at the basic principles, you can help yourself develop in design terms by looking at all kinds of visual material in the world around you, such as books, magazines, posters, store fronts, packaging, CD covers, and food and drink containers. Now think about who you are. How old are you? Where do you live? What kind of things do you like to do? Do you belong to different communities?

If you find certain designs attractive, then begin to analyze why. How are the graphic ideas being expressed through the use of color, typeface, images, and so on? It's likely that many of the designs that appeal to you have been designed to catch your eye—a graphic designer has been commissioned to come up with a design that appeals to a particular type of person—and if that person is you, then he has succeeded!

This introductory section of the book will give an overview of some of the guidelines and basic principles of good design, before we move onto the heart of the book: the projects.

Among the basic principles we'll explore are typographic considerations (typeface selection;

leading; simple typographic rules and ornaments); the "grid" (the underlying structure of a graphic design); images (selection and use); color (selection and use); space and arrangement (styles of layout; use of space); and paper and materials (surfaces for printing on).

One of the first principles is the size and shape you are going to work with. This is known as the format, and quite often this decision is already made for you: for example, letterheads are nearly always A4 or American letter and "portrait" format (tall and thin) rather than "landscape" (short and wide).

If, however, you have a free hand in choosing the format, then think about two elements: practicality, and mood.

The practical aspects include the economy of your chosen format—does it cut economically from a standard-sized sheet? If you are handmaking one or two items, then wastage will not be too significant a problem, but if you are printing dozens or hundreds of copies then having a lot of waste paper is also a waste of money. (Also, find out whether an unusual format will be easy to mail.)

The second aspect is the feel or mood you wish to create. If your content is mainly pictorial, then think whether the images fall naturally into a landscape or portrait form. Photographs of the countryside obviously suit a long horizontal shape (which is why it's

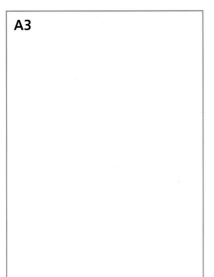

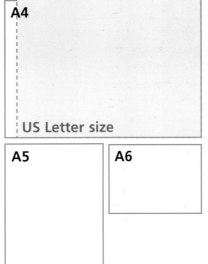

STANDARD FORMATS
European paper sizes use an "A" coding system, and you can see how they relate to each other in terms of proportions here. The largest standard size is A1, but if you have access to these paper sizes you are most likely to use A3 (11³/₄ x 16¹/₂in, 297 x 420mm) A4 (8¹/₄ x 11³/₄in, 210 x 297mm), and A5 (5²/₃ x 8¹/₄in, 148 x 210mm). US Letter size is 8¹/₂ x 11in (215.9 x 279.4mm)

A3

A4

US Letter size

A5

A6

# Principles of good design

called landscape format), whereas urban scenes with tall buildings suit a tall, vertical (portrait) format.

The format you use goes a long way toward dictating the mood of your design. For example, square formats have a modern feel, while unusual shapes, such as a circular format, conjure up speed and sporting connotations. Of course, you'll need to ensure that the format you choose won't be prohibitively expensive to print in large numbers. The old adage of form follows function (content) is very true in selecting the right format to work with.

The text is the next thing to think about: is there a lot of it? If so, which parts are most important? How can you reflect that in your design? If you are designing something like a newsletter or magazine, then you

**SQUARE FORMAT BROCHURE**
Square formats, like this one, can create an up-to-date, contemporary feel.

REVIEW HEADING

LISTINGS TEXT

REVIEW HEADING

SECTION HEADING

BODY COPY

QUOTE COPY

CATEGORIES TEXT

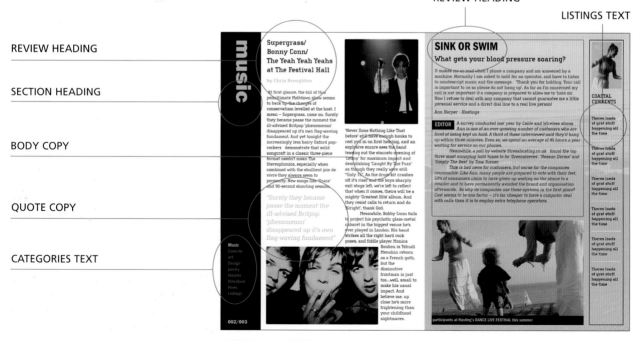

## music

### Supergrass/ Bonny Conn/ The Yeah Yeah Yeahs at The Festival Hall
by Chris Broughton

At first glance, the bill of this penultimate Meltdown show seems to back up the charges of conservatism levelled at the host. I mean – Supergrass, come on. Surely they became passe the moment the ill-advised Britpop 'phenomenon' disappeared up its own flag-waving fundament. And yet tonight the increasingly less hairy Oxford pop-rockers demonstrate that solid songcraft in a classic three-piece format needn't mean the Stereophonics, especially when combined with the ebullient joie de vivre they always seem to perspetly. New songs like 'Grace' and 90-second shouting session.

*"Surely they became passe the moment the ill-advised Britpop 'phenomenon' disappeared up it's own flag-waving fundament"*

Music
Comedy
art
Design
poetry
theatre
literature
News
Listings

002/003

'Never Done Nothing Like That before' still have enough hooks to reel you in on first hearing, and an explosive encore sees the band tearing out the staccato opening of 'Lenny' for maximum impact and demolishing 'Caught By The Fuzz' as though they really were still "Only IV. As the drum kit crashes off it's riser and the boys sharply exit stage left, we're left to reflect that when it comes, theirs will be a mighty 'Greatest Hits' album. And they resist calls to return and do 'Alright', thank God.

Meanwhile, Bobby Conn fails to project his psychotic glam-metal cabaret in the biggest venue he's ever played in London. His band strikes all the right hard rock poses, and fiddle player Monica Boshou is Yehudi Menuhin reborn as a French goth, but the diminutive frontman is just too...well, small to make his usual impact. And believe me, up close he's more frightening than your childhood nightmares.

### SINK OR SWIM
#### What gets your blood pressure soaring?

It makes me so mad when I phone a company and am answered by a machine. Normally I am asked to hold for an operator, and have to listen to nondescript music and the message. 'Thank you for holding. Your call is important to us so please do not hang up'. As far as I'm concerned my call is not important if a company is prepared to allow me to 'hold on'. Now I refuse to deal with any company that cannot guarantee me a little personal service and a direct dial line to a real live person!

*Ann Harper · Hastings*

**EDITOR** A survey conducted last year by Cable and Wireless shows Ann is one of an ever-growing number of customers who are tired of being kept on hold. A third of those interviewed said they'd hang up within three minutes. Even so, we spend an average of 45 hours a year waiting for service on our phones.

Meanwhile, a poll by website Stressbusting.co.uk found the top three most annoying hold tunes to be 'Greensleeves', 'Nessun Dorma' and 'Simply The Best' by Tina Turner.

This is bad news for customers, but worse for the companies responsible. Like Ann, many people are prepared to vote with their feet. 50% of consumers claim to have given up waiting on the phone to a retailer and to have permanently avoided the brand and organisation afterwards. So why do companies use these systems in the first place? Cost seems to be one factor – it's far cheaper to have a computer deal with calls than it is to employ extra telephone operators.

participants at Hasting's DANCE LIVE FESTIVAL this summer

COASTAL CURRENTS

Theres loads of grat stuff happening all the time

Theres loads of grat stuff happening all the time

Theres loads of grat stuff happening all the time

Theres loads of grat stuff happening all the time

Theres loads of grat stuff happening all the time

Theres loads of grat stuff happening all the time

need to evolve a style for each element—for example, headlines, introductions, captions, and so on—that you can apply as you go along.

Making it easy for people to extract meaning from your design is the next consideration—if they cannot read the words on your Web site then the viewer will quickly become frustrated and move on. The same applies to printed matter, where typeface, type size, and type measure are important factors in achieving good legibility.

There are some basic rules. For example, the optimum number of words per line for novels is 10 to 12. Any more than this makes it more difficult for the eye to pick up the next line. For other kinds of design, where the reading matter is broken up with images (illustrated books like this one, magazines, newsletters, and so on), a smaller number of words (say, five to eight) per line is acceptable. Typeface choice has a role to play here as it has a direct affect on the maximum number of words on each line). Narrow ("condensed") fonts allow more words per line.

Other factors influence legibility, such as color. Black text on a white background is the optimum choice for any large amounts of text that will be read continuously. Other color mixes are less successful for text: for example, blue text on a red background can be very difficult to read and often creates a clashing effect on the eye.

As you can see, design is a subject that has to balance the practical with the esthetic!

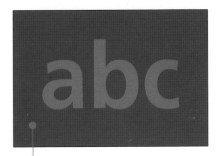

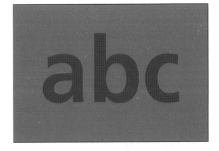

**COLOR AND TYPE**

Black on white is the easiest combination in terms of legibility of text. Some other color combinations are more difficult to read and can create an optical clashing effect.

# Designing your message

**The most important questions to ask yourself are: what is the aim of my project? What is it for? Who is it for? And what result do I want to achieve? Don't embark on any design until you're clear in your own mind about what your "message" is. The more informed you are about your audience, the better chance you have of a good reception!**

Your budget may have a major impact on what you can achieve. If you're making something at home in small quantities, then budget is not really a factor once you've bought your materials, but if you plan to take your work on disk to a local print shop, then the cost of printing it rapidly becomes very important. Full-color printing is more expensive than single or two-color printing, for example, and your choice of paper can also ramp up the cost.

Once you're aware of your objectives and your limitations, then the design work can begin in earnest! You can work directly onto the computer, but it is worth doing some planning beforehand.

You can split almost all design jobs into two broad categories: publicity design and information design. Of course, many jobs will comprise both elements, but it will help to think in these terms.

With publicity design—such as posters, flyers, and so on—the emphasis is on communicating a message, which is generally selling or announcing something to the public. The use of typography, images, and color here is much more dynamic.

## FINDING THE RIGHT STYLE

The choices you make in your design work will influence the way people think about your home business if you have one. So create the right look.

A piece of publicity design will also rely to a certain extent on a strong graphic idea (a concept). Try "brainstorming" some ideas in a short but intensive period of time. Draw and write down as many ideas as possible in 20 minutes without analyzing your decisions. (If you stop and think, you will prevent yourself from dreaming up new ideas.)

so on all fall into this category. Selecting the right column widths (the overall "type measure") is an important factor. Often information is in tabular form that will require careful thought in terms of typeface selection and size. Again, careful planning well in advance of starting work on the computer will pay dividends.

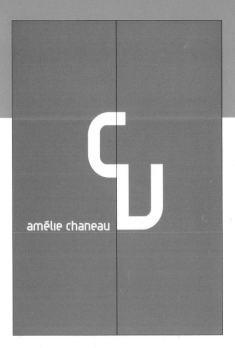

## Break up your text like this!

Once you've finished brainstorming, it is time to analyze what you've come up with. Discussing the ideas with friends and family—or your client if you have one—is a good strategy. In time you will be able to whittle your ideas down to a shortlist of potential candidates that you can develop further and play around with. Eventually, the winner will appear.

With information design, the emphasis is on relaying information in as clear and as precise a way as possible. Your challenge is to give people a "navigational" system they can use to locate and extract information. Designs such as forms, timetables, maps, memos, Web sites, instructions, letterheads, and

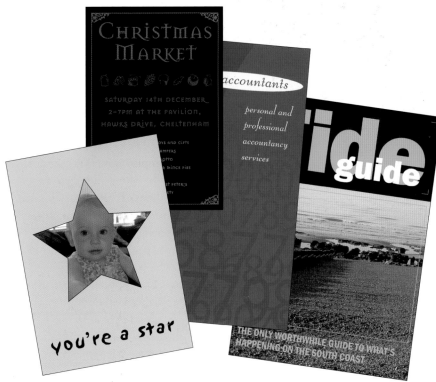

# The grid

One of the ways to achieve harmony and balance in design—particularly in jobs such as newsletters, leaflets, and brochures—is first to create an underlying structure. Every newspaper, magazine, or catalog you pick up is designed around just such a structure, known as a grid. On these two pages we've revealed the simple grid for this book.

When you create a grid you simply divide the page into columns and cells or units of space into which you can place all of the elements of your design—for example, text and images. The grid you use should give some order to all the pages but at the same time offer some flexibility so your design doesn't appear too rigid.

Although the grid itself will be invisible in the printed article, using it on every page of a publication means that all the diverse elements are organized according to the same rules, creating a visual harmony across every part of the design. You can see here how this book has been organized.

Your grid will include the margins, the space at the top, bottom, and edges of your page (and the space in the middle where you have a double-page "spread", or two facing pages). It will also indicate the column widths for

typesetting and images. The complexity of your grid will, to a large extent, be determined by the nature of your content.

When you are devising your grid on the computer, think about the number of columns you might need for the text. Make sure the column width is not too narrow or too wide (as a guide six to eight words per line is a good starting point for newsletters and magazines). You'll see various suggested grids throughout the projects later on in this book.

## Think about your structure

Construct a double-page spread (two facing pages) and ensure that the grid does not create too large an empty space in the middle when the pages are viewed next to each other (as they will be).

When you come to place text and images onto the grid, make sure you use the full width of each

column. However, the real secret of grids lies in how you use the columns and cells. For example, on a four-column grid you might decide to run your text right across the width of three columns, wrapping around an image that is stretched across two columns, and then use the fourth column for image captions—or perhaps just leave it empty. There are hundreds of possibilities, which is where your creativity comes into play! The important thing to remember is to stay within the structure of the grid at all times.

If you find yourself constantly trying to go outside the structure of the grid when you're working on your designs and layouts, then you may need to go back to the grid and make adjustments to give yourself the room to be more flexible. You may need to adjust it several times before you have a grid that works.

## THE BOOK GRID

We've designed this part of the book on a three-column grid that gives us plenty of room for text and images. It doesn't need to be more flexible.

## THE BASELINE GRID

Some page-layout programs have what's known as a baseline grid system, which your horizontal lines of text should sit on.

**Heading**

14 15

# Color and reproduction

**Nowadays, you can print in full color on your desktop ink-jet or color laser printer (if you have the latter), but until quite recently black and white photocopying was the most that many "home publishers" could hope for!**

**THE CMYK SYSTEM**
Cyan, Magenta, Yellow and blacK (CMYK) is the four-color system used in professional print reproduction.

**THE RGB SYSTEM**
Your computer monitor displays color using combinations of Red, Green, and Blue (RGB) dots.

While it might seem inexpensive to print at home, if you run out a lot of full-color copies on your desktop printer then you'll quickly use up color ink cartridges, which can be very expensive to replace.

If you want dozens or even hundreds of copies, then you'll find it's far more practical and economical to take your work on disk to your local print shop. If you do, then you might also find (depending on the system they're using) that printing in full color is more expensive than printing in one or two colors. As we'll see in the projects, you can maximize the impact of just one or two colors by using tints.

Before taking your work to a print shop, check first what format they want the file to be in, and double-check with them that the fonts (typefaces) you've chosen are not going to be a problem. In most cases, the simplest thing to do to avoid any problems is to make a PDF file of your design—which you can do in many image-editing, illustration, and page layout applications. Check your software manual for more information.

In practice, printing in "full color" means using a process called "CMYK", which stands for Cyan, Magenta, Yellow, and blacK. These are the four inks that, when combined, produce the illusion of full color. The "K" is used to denote black to avoid confusion with blue.

When you are viewing your work onscreen, however, you're using a different color system, known as RGB (Red, Green, Blue). This is the three-color process that your computer monitor uses to display the illusion of full color. It's best to work in RGB on your desktop and then convert the finished design to CMYK for printing as, this way, the onscreen colors will be more accurate.

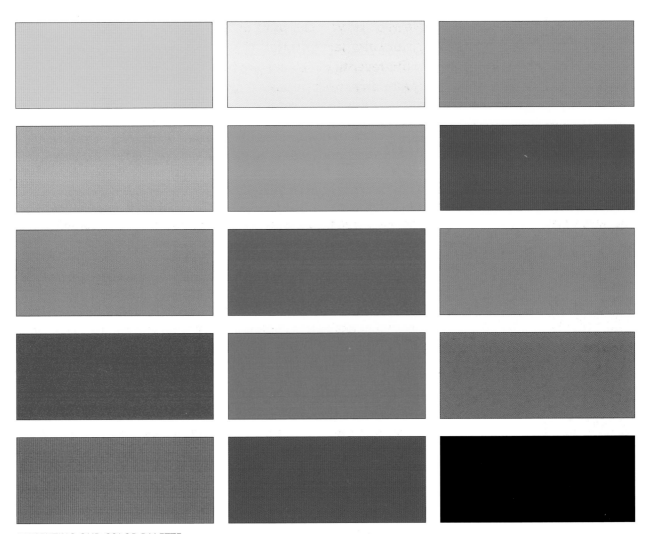

## PRESENTING OUR COLOR PALETTE

For extended publications, such as books, magazines, catalogs, and so on, it makes sense to create a palette of colors to use. Here's the palette for this book.

# Color and reproduction

**COLOR "SWATCHES"**
Many software packages give you their available palette of colors to use.

**PALETTES**
You can create your own palette of colors for your designs in some other software packages.

However, because the two systems are fundamentally different, you may find that the way your colors appear onscreen will not be reproduced quite the same at the printing stage. Screen colors often appear to have a greater degree of brightness and a wider tonal range than their printed versions.

## Working with color

Let's explore some basic color theory to help you create designs that work. Color can differ in three ways: hue (red, blue, and so on); tone (the degree of lightness or darkness); and saturation (the amount of brightness or dullness in a hue). Put these three aspects together and the number of variations is almost infinite. On larger design tasks (newsletters, catalogs, and magazines), it's a good idea once you've created your grid to also put together a palette of colors that you can use throughout your design, particularly if it's going to be a regular publication.

Color wheels are included in most desktop software programmes designed for imaging work. These can be an invaluable reference when exploring and experimenting with color combinations and choosing the colors for your design.

In printed materials, primary colors are the three colors from which all others can be made, namely red, yellow, and blue (computer monitors are different, as we've already explored). Secondary colors are a mix of two primaries, creating orange, green, and violet. Tertiary colors are a mix of a primary and a secondary, or a mix of two secondaries, resulting in colors such as olive green, russet brown, and citrus.

Colors opposite each other on a color wheel are known as complementary (red/green, yellow/violet; blue/orange), and those adjacent to each other are known by the term "analogous" (yellow/green, red/orange, violet/blue).

## Complementary colors

The effect of using complementary colors will be strong, bright, and aggressive, because the colors have a contrasting effect. Using analogous colors creates a softer,

more harmonious feel. Think about what effect you want to create with your design, and about who you want to attract.

You can make images either leap off the page or recede into the background using the same approach: highly contrasting, complementary colors between image and background will make the image stand out, while analogous colors will have a much subtler impact.

## The obvious route

Sometimes, it pays to take the obvious route when you're selecting colors. In general, reds, oranges, and yellows have a warm feel, and reds in particular have an intense, sometimes aggressive character. Greens are generally said to be cooler and more relaxing— but some studies show that people don't respond very well to green on the covers of books and magazines. Blue can be a cold color, but it is often used on "corporate" designs as it is smart while not prompting a strong response either way. It can be a safe choice.

Collect color combinations that you like, or which you feel are successful—think about what logos or brands you respond to and consider using the same mix of colors in a design of your own. There are countless color matching systems available in book form that will give inspirational examples.

Color is vital in information design, where it can direct the eye to the most important elements. You can prioritize information with a prominent hue, such as red, and use a less "advancing" color for less important information. Web sites, maps, graphs, signs, and tables all benefit from the way color can "code" the information.

The final aspect to consider with color is the legibility, where high contrast is usually the key. A black image on a white background, or yellow out of black, will give you maximum contrast, while yellow on white gives you minimum contrast.

Remember that onscreen viewing may give you a bright and apparently legible design, but this can reduce drastically when it is reproduced in print.

COMPLEMENTARY COLOR

ANALOGOUS COLOR

# Images

**We've all heard the expression "a picture paints a thousand words." In graphic design and page layout, that is certainly true. In magazines, brochures, catalogs, or newsletters, a featureless "wall" of words is something that most people won't bother reading, but run the words alongside an attractive picture and you've won yourself a reader.**

Images exercise power in design, partly because they attract and inform much more quickly than the printed word. People tend to flick through magazines, newsletters, brochures, and catalogs, and will only stop to read something in more detail if it grabs their attention.

We have become used to images in the media as an integral part of everyday communication—we can even communicate with images via our phones. Tabloid newspapers and magazines are known for their visual content, but increasing numbers of "serious" newspapers have become reliant on reinforcing their stories with pictures.

With today's affordable digital cameras, you can shoot your own images, download them onto your computer, and work with them almost instantly. This gives you tremendous creative control.

Adobe Photoshop, Photoshop Elements, and other desktop image-editing programs (you should already have some basic image-editing tools preinstalled on your computer) are flexible and give you almost limitless creative potential. But for any image to be effective it should tell a story or make the reader think. This is where your own thought processes need to be put to work! What exactly are you trying to say to the viewer in pictorial terms?

One of the good things about digital imaging is that you can see the image immediately, which gives you the potential to experiment;

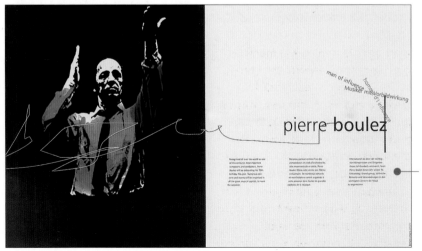

**STUNNING IMAGES**
Here's an excellent example of inspirational image use combined with good typography to create a design that has enormous impact.

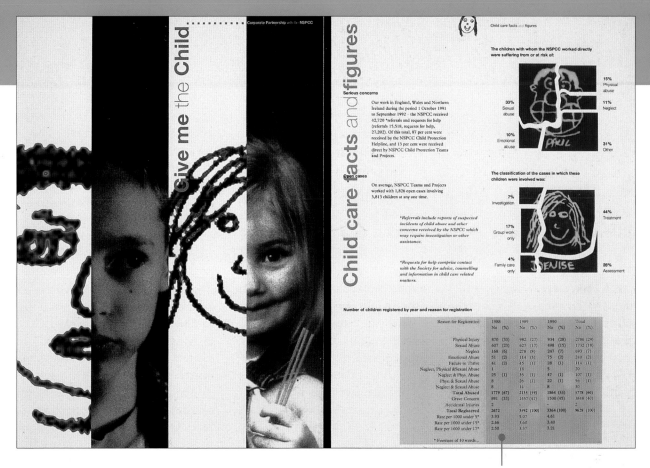

but remember that quantity is not necessarily quality. Before taking any images try to exercise discipline by thinking about what you are trying to achieve before firing the shutter. Taking lots of shots randomly can be counter-productive. Even your experiments should have some overall objective.

Think about the composition of your image, as well as that of the page. What is the main point of interest in the image? In many cases, you can reinforce the impact of your subject by editing it to create a more dynamic composition, losing any elements that don't add to the "story." Look at how photographs are used in magazines and newspapers for inspiration.

For example, your main subject could be off-center in an asymmetrical arrangement, or you could crop very tightly in on

### GET INSPIRED BY WHAT'S AROUND YOU
Here's a very clever example of a design based on a combination of children's drawings with photographs of the children themselves.

# Images

**CROPPING**

You can change an image completely, or create an entirely new view of it, by "cropping" it. This means selecting and using just a part of the image within the frame.

someone's face. Cropping is where you lose unnecessary parts of an image to create a better or more interesting composition.

Think of the frame as a doorway or a window in your wall of text, and think about how you would like your subject to appear in that space. Perhaps look for strong diagonal lines in the image, which could give the page more "movement," making it less static and formal. Showing the subject only partially can sometimes add intrigue and visual interest.

You can also use your editing software to change the color balance, brightness, contrast, hue, and saturation of your images, but why stop there? The digital age is removing the boundaries between photography and illustration and you are just a few mouse clicks away from turning your photos into graphics in a broad range of styles and moods. The only limits are in your imagination. In the projects we'll look at using images "as is," and also as source material for logos and graphics. If you don't have the confidence or time to originate images yourself, one

alternative is to use photographic libraries, of which there are several in the marketplace. Most are very expensive, but some (such as flickr and iStock) are either inexpensive, or give you the option of contacting photographers all over the world. Some sites allow you to purchase a royalty-free CD of images for a one-off cost, meaning you don't have to pay for each image you use. Another more practical and less expensive alternative is to get to know a keen amateur photographer in your local area!

The design of graphs, diagrams, and other graphic elements should be given the same consideration as any other part of the design. There is a temptation to sit at your computer and construct illustrations without any preconceived plan. This can work, but a better strategy is to produce a layout before the actual work of making the illustration begins.

First decide which type of illustration would best suit your needs and then draw up some ideas. Design points such as what size, colors, shading, and perspective to use can be evolved at this stage.

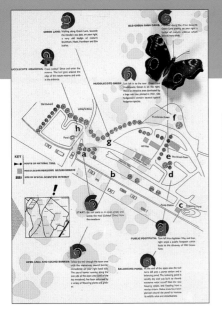

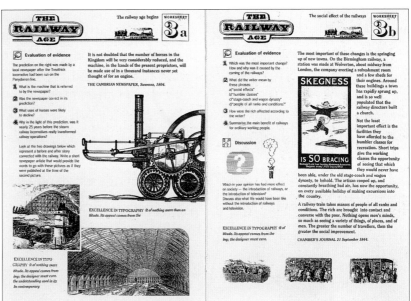

## COMBINING IMAGE TYPES

This map, above, combines illustration and photography, while this heritage publication, right, uses old-fashioned elements in a modern way.

Keep a good stock of illustrative examples or references from books to guide you.

You might find you prefer to draw things freehand on paper and then scan in your drawing onto your computer. Get an artistic friend involved—on some projects you can perhaps even use children's drawings. Another option is to scan found objects, such as leaves and flowers, or a textured surface that you like to use as a background for a layout. Once in your computer, you can edit, crop, and manipulate the image any way you want.

If you're drawing the illustration yourself (on the computer, or freehand for scanning), then use black for the main drawing and add color afterward, perhaps in the computer. Using varying tones of color is a good way of depicting different layers of information. Simple ideas are best to start with, and you can always add elements once you have constructed the basic shell of the idea.

The minimum type size you should consider for diagrams or illustrations is 6 or 7 point. Sans serif fonts are more legible than serif fonts at small sizes.

# Layout and typography

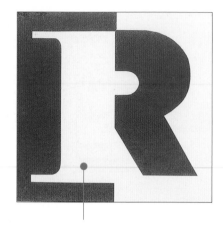

**TYPOGRAPHY AND DESIGN**
Your choice of font is a vital consideration in any design: is it right for the design? Is it legible? Can you combine it with another font on the same page?

**When you're creating layouts for text-based projects, such as brochures, magazines, and newsletters, you have two elements to deal with: your content in the form of images and text, and what is left over—namely space. How well you balance and arrange space and content is the key to a successful layout.**

Space is also important in the typesetting of the "display" text (headlines, and so on) and the main text. Your aim is to achieve an overall visual balance and, for some graphics such as posters, dynamism and flair.

It's an oversimplification, but essentially there are two styles of layout: symmetrical and asymmetrical. In the symmetrical style, everything is positioned centrally in the design—if you draw a line down the middle of page the content would be equally balanced on either side of the line.

In terms of the type of designs you'll be dealing with, this style is mainly associated with a conservative, traditional approach (which may be what you're after). Typefaces here are usually "serif" fonts, with their characteristic ornaments or typographic flourishes embellishing the layout. Times and Times New Roman are examples of common serif fonts, while others of this style are much more ornate.

Although this layout style has associations with the past, it is still used today in textbooks and novels, and also in wedding or event invitations and formal announcements where a traditional approach is usually required.

As you might imagine, an asymmetrical layout means the arrangement is off center, which creates more visual options and a more dynamic impact. This type of design is not a recent innovation; in fact, it has its roots in new approaches to design, architecture, and typography that began in Europe in the 1920s.

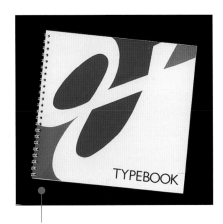

## TYPE AS DECORATION

Here's an example of a design that uses type to communicate and also as a decorative element.

## CREATIVE TYPOGRAPHY

Experiment with unusual layouts.

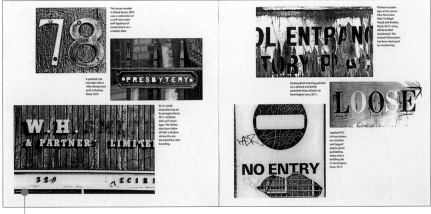

## A WELL DESIGNED BOOK ABOUT TYPE

An unusual approach to how type communicates, with examples.

# Layout and typography

The new thinking ushered in the widespread design and use of fonts that are "sans serif" (without embellishments). Gill Sans, Helvetica, and Futura are examples of common sans serif faces. Compare them with Times on your computer and see the difference.

This page, for example, is set in a sans serif font called Frutiger.

You can find hundreds of typefaces on the Internet, and also on some design or computer magazine cover disks. Unless you need them for a specific reason (such as designs for children, perhaps), avoid choosing font styles that are too "whacky," jokey, or unusual as they may cheapen your design work rather than make it look more attractive. Choose

appropriately and keep your eyes open for how design professionals make their designs look good.

All typefaces are available in different "weights," such as **bold**. *Italic* settings create an attractively slanted version of the typeface, which can be used in a variety of ways that you will be familiar with from books and magazines.

Today, asymmetrical layout styles are very popular. With more flexible rules, your type can be "ranged" left or right rather than be made to stretch over the entire width of a column, for example, or be centered.

In fact, there are four ways of setting type within a column: ranged left, ranged right, centered, and justified. In the latter case, the type is aligned to both left and right edges of the column, forcing the text to stretch across the full width, regardless of how many words fall in each line.

Each option means balancing conflicting demands: aligning your text left, for example, will give you a "ragged" edge on the right but even word spacing, whereas justified text will give you clearly

GILL SANS

ABCDEFGHIJKLMNOPQRSTUVWXYZ
abcdefghijklmnopqrstuvwxyz
1234567890

FUTURA BOOK

ABCDEFGHIJKLMNOPQRSTUVWXYZ
abcdefghijklmnopqrstuvwxyz
1234567890

TIMES

ABCDEFGHIJKLMNOPQRSTUVWXYZ
abcdefghijklmnopqrstuvwxyz
1234567890

## FRUTIGER 55 ROMAN

# ABCDEFGHIJKLMNOPQRSTUVWXYZ
## abcdefghijklmnopqrstuvwxyz
## 1234567890

## FRUTIGER 65 BOLD

# **ABCDEFGHIJKLMNOPQRSTUVWXYZ**
## **abcdefghijklmnopqrstuvwxyz**
## **1234567890**

## FRUTIGER 46 LIGHT ITALIC

# *ABCDEFGHIJKLMNOPQRSTUVWXYZ*
## *abcdefghijklmnopqrstuvwxyz*
## *1234567890*

defined vertical columns and lines, but uneven word spacing. Justified text (which you'll find in most novels and textbooks) is smart and straightforward, but you may have to work hard to create breaks in the middle of some words and not lose their meaning.

However, problems only really occur in justified text if the measure (column width) is too short for your preferred type style, or the type is too large, causing excessive word space to occur. Over a whole page, "rivers" of white will appear in the text, which will be both ugly and make your text much harder to read.

**TEXT RANGED LEFT**
Aligning your text left will give you a "ragged" edge on the right and even word spacing.

**TEXT RANGED RIGHT**
Aligning your text right will give you a "ragged" edge on the left and even word spacing.

**CENTERED TEXT**
Aligning your text centrally can be useful on some designs, such as invitations, but is not advisable for large amounts of text.

**JUSTIFIED TEXT**
Justified text will give you clearly defined vertical columns and lines, but uneven word spacing (as you can see here). Justified text (which you'll find in most novels and textbooks) is smart and straightforward, but you may on occasion have to create breaks in the middle of some words, while not losing their meaning, or amend your text to fill out the lines better.

# Layout and typography

If you want a modern feel to your designs then asymmetrical layout styles are probably most appropriate. Magazines, leaflets, and information design can all benefit from this approach.

Remember that most people have become visually literate, because our lives are saturated by everyday exposure to magazines, signs, Web sites, logos, books, posters, newspapers, and catalogs.

If you use an overtly traditional or conservative style, then people will interpret that as deliberate and read meaning into it. Think about your audience and your message!

Once you've created your grid you can think about allocating space, which you can use to isolate pictures from text, or to concentrate content (and the eye) on a particular area of the page. Your use of space can create

contrasts between different pages and double-page spreads—some can be packed with information and others can be left emptier (as long as they all conform to the underlying grid).

**WHEN YOU SHOULD KERN**
At large sizes, gaps between letters can become unattractive. "Kerning" can aid your design by reducing individual gaps.

# kerning
# kerning

leading is the space between lines
leading is the space between lines
leading is the space between lines
leading is the space between lines
leading is the space between lines
leading is the space between lines

**EXAMPLE ONE**
Shallow leading looks like this.

leading is the space between lines

leading is the space between lines

leading is the space between lines

leading is the space between lines

leading is the space between lines

leading is the space between lines

**EXAMPLE TWO**
Deep leading creates this effect.

Space within your typesetting is a vital consideration—letter, word, and line spacing are part and parcel of what typography is all about. In display type (sizes from 14 point upwards) poorly spaced type will be a glaringly obvious design flaw—the eye will concentrate on the unevenness of the spacing rather than the shapes of the words. As type size increases, so does the likelihood of the spacing becoming more uneven.

In some programs, you can address the "kerning" (the term given to adding or reducing space between individual characters); in others—such as most wordprocessing programs—the type-editing functions are surprisingly limited. "Tracking,"

found in some programs, changes the spacing between all letters.

Sans serif fonts can be set closer together because of the absence of ornamentation. Of course, you can take the decision to make wide letter spacing a design feature.

The amount of space between lines of text vertically is called the "leading". In main text typesetting try not to use the Automatic mode that many page-layout programs give you. Make a decision to set a specific leading figure. Play around with different settings and look at the effect on your design: leading can improve the legibility and attractiveness of main text and other text elements, and it can also bring light and space into cramped designs.

# Paper

**Having a bit of knowledge about paper and materials will really open up the whole world of design to you. As your graphics and layouts are more than just the visuals—they are also what they are printed on.**

WHAT PAPER IS THIS?
The paper this book is printed on is 130gsm (that's the weight) Japanese Matt Art paper. Feel the surface and look closely at how the type and images sit well on this coated stock.

Consider the different effect of a magazine printed on thin, flimsy paper compared with one printed on a thick, glossy paper stock. The former implies something disposable—a weekly listings magazine, perhaps—while the latter suggests a sophisticated monthly you might want to keep. A business card printed on a thick, subtly textured, cream-colored stock might be handed out by a person of status, while a card printed on inexpensive, or boring stock might suggest a lack of imagination, perhaps even a less important person or company.

However subjective such judgments might seem, people do make them. Your choice of material may subtly influence people's opinion, because they have become familiar with the "codes" of certain items: inexpensive, high-volume materials suggest inexpensive, high-volume products. A bit of imagination, without going too far or breaking the bank, will always grab people's attention!

If you want to be serious about it, most paper manufacturers produce "swatch" (sample) books for reference purposes, but it might be simplest to pay a visit to your local print supplier or stationer and spend time looking at what's available. If you want to print at home on your desktop ink-jet or laser printer, then you might be surprised how many materials are compatible. If in doubt, ask: there's no point wasting money on an attractive paper that produces a poor-quality, smudged print, or which your printer mechanism damages or tears apart.

Keep samples of things printed on papers or materials you like: look for items with different types of content—mainly images, or mostly text. How does the color look on the different paper stocks?

Collecting samples can be a good starting point for ideas. Your choice of paper can either enhance the quality of the design, or perhaps detract from it.

Another over-simplification: paper can essentially be divided into two distinct surfaces: coated, and uncoated. Coated papers are given extra treatments in their manufacture that enable the surface to be smooth. The degree of smoothness can be likened to paint finishes—gloss, satin, or matt. Gloss papers have the shiniest finish, satin is less shiny but still smooth, while matt will appear duller by comparison.

The main difference between gloss, satin, and matt is in the brightness of the images you can achieve—in general, the glossier the sharper, although all three generally give good results on photographs, particularly in terms of brightness, tonal values, and color saturation.

Deciding between the three is in some ways a question of the mood you want to create. Gloss paper, with its reflective appearance, used to be the most popular finish, but in some parts of the world it is now seen as lacking in subtlety, and satin and matt finishes have become more popular.

Uncoated papers have a rougher surface, and the appearance of colors and images will be less bright than on coated stocks—but that can be an attractive choice, as the attention becomes focused on the thing itself and its tactile quality. In general, uncoated stocks are ideal for jobs such as newspapers, newsletters, stationery, and certificates. Your letterheads will be (hand)written on as well as printed on, so the surface also needs to accept ink!

Some papers, particularly uncoated ones, are more absorbent than others. This inevitably means they absorb more ink, which can create what is known as "dot gain." Most printing processes and technologies (such as your ink-jet printer) build up the illusion of full-color images by layering patterns of different colored dots on top of each other—take a look at a newspaper page through a magnifying glass. Just as a dot of ink on a piece of blotting paper

**PAPER AND DOT GAIN**
Some paper is more absorbent than other paper, and so ink printed on absorbent paper can spread out—just as fountain pen ink does on blotting paper. This is known as "dot gain." See if you can spot any here.

# Paper

**PAPER AND "SHOW THROUGH"**
Thin paper can have "show though" where you can see what is printed on the other side. Can you see the large "i" through here? Hold this to the light.

spreads out and gets bigger, so do the tiny dots of ink on more absorbent papers. "Newsprint" (the common name for the paper used for most newspapers) is very absorbent, as you will see if you take a close look at the printed dots through a magnifying glass.

This might become a problem for very fine text or subtle line details as they will seem thicker and less well defined when printed. Images, too, might seem muddier and less distinct. If you're set on a specific paper that has a noticeable dot gain, you might need to adjust your design to compensate.

Further considerations when making your choice of paper are its thickness or weight, and its cost to buy, of course.

Many papers are available in a range of weights (thicknesses). This is important in stationery where the letterhead will use a lighter weight of stock than your business cards and envelopes, for example, but you might want to have exactly the same surface. For some publications you might choose a heavier weight of paper for the covers.

Very thin papers often have "show-through," in that you begin to see what has been printed on the reverse side of the paper. This can make text-based designs confusing to look at. Thicker, bulkier papers will be much heavier over the course of a whole document. If you are doing a mass mail-out, this might create unwanted expense.

Promotional work can be given an extra dimension by the use of colored paper or by using one of the many unusual, handmade, or "special effect" papers that are now available. There are metallic papers, cover papers that have twin surfaces of different colors, heavily textured papers, and so on. If you opt for something like this you may have to reconsider your printing method!

If you keep notes and samples of all of your experiments with paper, you will not only build up valuable knowledge, you will also be able to advise others!

## SPECIALIST PAPERS

You can buy paper in any color and a whole range of specialist surfaces, including metallic. Doublecheck that you can print on the stock you choose.

# PROJECTS

# 01 -14 →

## Just in bloom

Bouquets, Floral Tributes, Weddings, Special Occasions

Hastings Physiotherapy Clinic

Matthew Herriott MCSP SRP   t 07981230105
Lesley Barnes MCSP SRP   t 07913188972

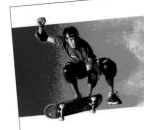

SKATE GEAR

Thomas Partridge
98 Western Road
Cambridge
Mass USA

*ks accountants*

122 East Block
Sheridan Avenue
New Town
NT227

T: 0870 67651
F: 0898 78521

fax 01424 234567

# LETTERHEADS

You never get a second chance to make a first impression. If you run a home business, then think of your letterhead as being the welcome mat in your doorway. When clients open up a letter from you they will not only read what you have to say, but also gain most of their first impressions of your business from the letterhead. Is it smart, discrete, and corporate? Is it bright, colorful, and welcoming? Or is it youthful, trendy, and contemporary? Choose wisely! Whichever mood you go for will be the first impression your business creates. If your letterhead is just for you as a personal statement, then it's equally important that the design reflects who you are to the people you write to.

# Letterheads: serious

**For small home businesses like accountants, domestic architects, builders, or therapists, the key messages are smart, reliable, and sensible. You are providing an essential service, so you need to make a professional impact.**

### GETTING INSPIRATION
Look at other letterheads you have received from banks, insurance companies, or doctors for inspiration.

One thing to bear in mind for this type of design is that while your letterhead should be sensible and serious, it should not be boring: you are providing a professional service, but also a personal one. Here we have taken inspiration from the shape of the logo to draw a stylish curve that sweeps down the left side of the page. (One way of doing this is to create a solid block of color, and then draw a very large circle filled with white that continues off the page.) This draws attention to the logo, while also directing the eye down toward the letter itself.

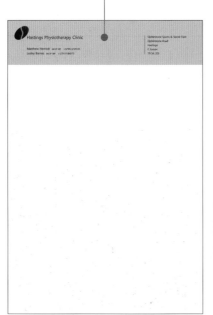

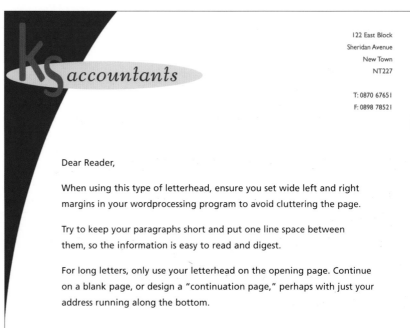

122 East Block
Sheridan Avenue
New Town
NT227

T: 0870 67651
F: 0898 78521

Dear Reader,

When using this type of letterhead, ensure you set wide left and right margins in your wordprocessing program to avoid cluttering the page.

Try to keep your paragraphs short and put one line space between them, so the information is easy to read and digest.

For long letters, only use your letterhead on the opening page. Continue on a blank page, or design a "continuation page," perhaps with just your address running along the bottom.

➡ **SEE ALSO: 68, 78, 86, 148 for related designs**

## CLEAR ADDRESS INFORMATION

Make sure contact details are easy to read—your customer may not have perfect eyesight. Here we've used the clean, crisp font Gill Sans.

## FOLDING A LETTERHEAD

Always remember that letter paper will be folded into three to fit into a business envelope. Make sure no essential element will be spoiled by the folds, and that your design considers how the paper will be used.

## SELECTING A COLOR

Stick to subtle shades of a single color: they will be easy on the eye, and cheap to print. Some blues are a good choice. Avoid bright reds or yellows.

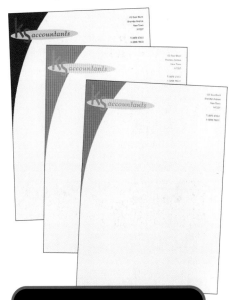

## CHOOSING A FONT

Sans-serif-style fonts (below, top) are clean and lack the characteristic ornamentations (serifs) of serif fonts (bottom). Either style will work so long as the font has a "classic," contemporary, businesslike feel—and is easy to read!

ABCDEFGHIJKLMNOPQRSTUVWXYZ
abcdefghijklmnopqrstuvwxyz
1234567890
ABCDEFGHIJKLMNOPQRSTUVWXYZ
abcdefghijklmnopqrstuvwxyz
1234567890

## OTHER POINTS TO CONSIDER

- Try photocopying your design to see if it reproduces well on a copier. Your customers may do this, or want to fax your letter.

- Bear in mind the change in some colors when you use a tint—e.g. red becomes pink.

# Letterheads: colorful

**Other types of small or home business have a different message: bright, colorful, personal—perhaps fun. Florists, party organizers, and children's entertainers all fall into this category, so make your letterhead work for your market.**

## ALTERNATIVE DESIGN

Here's a different layout that uses a vertical band in one quarter of the page. This is certainly an approach to consider, but we've rejected it in favor of the more friendly, brighter option.

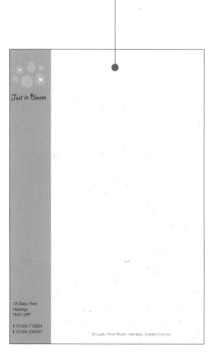

Bear in mind that some businesses, such as florists and flower arrangers, need to cater for a whole range of occasions, from the happiest—weddings, birthdays, and anniversaries—to the saddest. If this is part of your home business, then remember to make your design appropriate to all of these occasions: appealing for parties and celebrations, and yet tranquil and sensitive for less happy times. It is best in these instances to use subtle colors and shades to create a professional and sophisticated first impression.

## Just in bloom
*Bouquets, Floral Tributes, Weddings, Special Occasions*

Dear Reader,

In our letterhead design we've created a contrast between the lower case "b" in "bloom" and the upper case initial letters in our "strapline."

The strapline here is the line of text that sets out the business's products or services, but it might be a business motto or your company's "philosophy."

The font we chose for the logo is Dax Condensed Light, an attractive sans serif face.

Running the contact details along the bottom counterbalances the strong "masthead" logo at the top. The extra floral decoration in the bottom corner draws all of the design elements together and ensures the address information is not ignored.

13 Daisy Row • Hastings • TN37 2PP • tel 01424 715894 • fax 01424 234567

## THE GRID
With any letterhead, create an underlying grid for your design as we explored in the introduction. This will guide your design, but also how you type onto the page when you use it as a template on your PC.

## USE GRAPHIC ELEMENTS
An obvious touch, but one that says your business is tasteful, subtle, and appropriate to every occasion. Use clip art, draw freehand flowers in a painting program, or perhaps scan petals and foliage and use the shapes.

If you're ambitious for your business, then you might want to branch out into a range of related products or "feel good" elements. Graphic elements such as flowers and foliage lend themselves to applying to wrapping paper, labels, cards, and tags—all items that you will need in a flower business, for example. Reusing graphic elements will create the impression of a themed and comprehensive service that considers all of your customer's needs.

## OTHER POINTS TO CONSIDER
• Experiment with graphic elements on the page—explore using them in very pale color tints that could sit behind the text of any letter. You can create tints in any drawing program and many wordprocessing programs by setting a percentage of your chosen color.

• Remember that the more colors you use, the more expensive the design will be to print at your local print shop, as it will require more inks. If you are running letterheads out of your desktop printer, you will run down your ink cartridges more quickly when using more, or stronger, colors.

• Consider other uses to which your letterhead might be put—you could use it for invoices as well as business correspondence, for example.

• Check to see that your letters are still legible when photocopied.

# Letterheads: youth

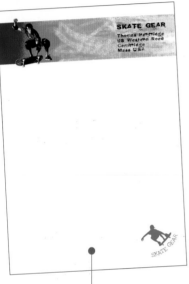

**Another world of business is the trendy, youth-oriented service, or one that is aimed at a choosy, specialist audience. In both cases, feel, plus the right terminology and image, are key factors in your customer's decision-making process.**

We've chosen to do a letterhead for a skate equipment supplier—our homeworker makes and customizes skateboards and also imports a select range of accessories and clothes from overseas. This business crosses over both the youth market of teenagers and young adults who want to impress their peers, and also the specialist adult market. The letterhead needs to reflect a service that's trendy and in the right style for its teen audience, while also reflecting an aspirational, lifestyle element for serious, older skaters. Teenagers will respond to this too.

**THE ELEMENTS**
We've run the logo in a subtle tint. Using a photo has added sophistication.

**THE LOGO**
Here's the logo, created by tracing a photo in a drawing package, or by importing and editing it in Photoshop.

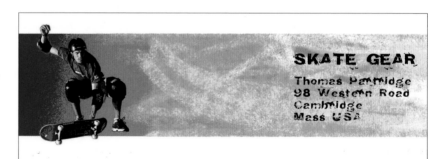

 **SEE ALSO: 58, 74 for related designs**

### FIND AN IMAGE

If your home business targets a specialist market, then perhaps source a digital photo (or scan a print) that reflects who your business is aimed at. In your image-editing package, select the main part of the image using a wand or marquee tool and cut it out of the background. You can then import or paste the clip onto your letterhead design, either in the same package, or in a wordprocessing program like Word.

### CHOOSING A FONT

Here's a range of font ideas that each reflects an edgy, contemporary feel.

THOMAS PARTRIDGE
98 WESTERN ROAD
CAMBRIDGE
MASS USA

Thomas Partridge
98 Western Road
Cambridge
Mass USA

THOMAS PARTRIDGE
98 WESTERN ROAD
CAMBRIDGE
MASS USA

Thomas Partridge
98 Western Road
Cambridge
Mass USA

### ADD A BACKGROUND

Backgrounds like this are easy to create in even the most basic image-editing or digital illustration package. You could scan a textured surface, or use one of the filters or specialist brush tools in your software to create a textured wash of color. Here we've used a watercolor-style brush.

### OTHER POINTS TO CONSIDER

• As with previous letterheads, photocopy a printout of your design and check that any address details sitting on top of a band of color remain legible in the photocopy.

# Letterheads: inspirations

**Let's look at some good examples of letterheads by professional designers to get some inspiration and creative strategies. These are all approaches to evolving designs that are appropriate, but which also catch the discerning eye.**

As these examples demonstrate, good design is about finding an appropriate visual expression of an idea, a concept, or a mood—but without necessarily being obvious or didactic. All of these professionally commissioned designs strike the right note for their clients, but they convey a message subtly and in the context of a smart, upmarket design.

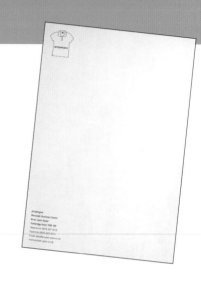

**APPROPRIATE AND UNDERSTATED**
Evocative design for this French archive institution, by design studio Trafik.

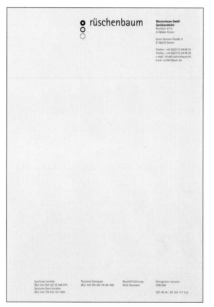

**THEMATIC, BUT SUBTLE**
Abstract corporate design for German piping manufacturer, by the UK's HDR.

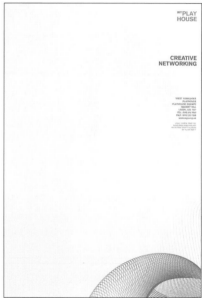

**FRESH AND HIGH-TECH**
Upmarket thinking for this UK-based theater group, by Thompson Design.

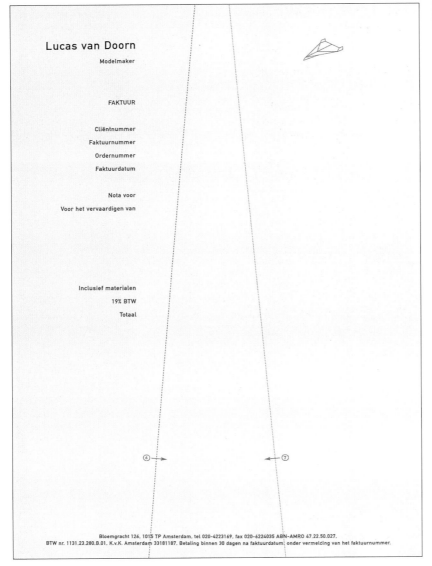

Lucas van Doorn

Modelmaker

FAKTUUR

Cliëntnummer
Faktuurnummer
Ordernummer
Faktuurdatum

Nota voor

Voor het vervaardigen van

Inclusief materialen

19% BTW

Totaal

⑥→          ←⑦

Bloemgracht 126, 1015 TP Amsterdam, tel 020-4223169, fax 020-6224035 ABN-AMRO 47.22.50.027.
BTW nr. 1131.23.280.B.01. K.v.K. Amsterdam 33181187. Betaling binnen 30 dagen na faktuurdatum, onder vermelding van het faktuurnummer.

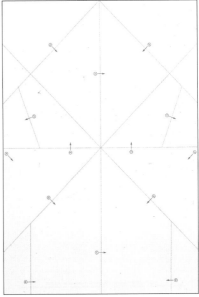

**REVERSE SIDE**
Everything is source material for this
modelmaker, suggests the design.

**FUN BUT SMART**
A design reflecting creative joy for this
Dutch model-maker, by KesselsKramer.

amélie chaneau

## Left document

Amélie Chaneau

**PERSONAL DETAILS**
Date of Birth: 4th February 1980
Address: 38, Quai d'Orsay, F - 75351, Paris
Telephone: 33 1 42 56 64 64

**CURRENT POSITION** June 1999-present
Senior Designer for Design Bridg...
I'm currently working on a 208 page b...

**PREVIOUS EXPERIENCE** Jan 1999-June1999
Senior Designer for Bridgewater...
My responsibilities included the conc...
including series and pocket guides. A...
photography as well as the art direc...

Nov 1998-Jan 1999
Freelance Designer for The Wel...
Responsibilities as outlined below in...

May 1998-July 1998
Freelance Designer for Christi...
I was assigned a variety of design jo...
the transport sector. Each project...
and allocating the workload amon...

May 1997-Oct 1997
Senior Designer at the in-hou...
My responsibilities involved...
invitations to full-colour exhibition...
and posters.

May 1996-April 1997
Design Team Lead on 'I Love...
I was responsible for the overall...
that the scheduled deadlines were...

April 1994-May 1996
Senior Designer of 'Mindpower' Timeli...
My role as Senior Designer on this 20-volume...
commissioning and art directing as well as gen...
I was also highly involved with presentation we...

**SKILLS**
I have full computer literacy in Quark XPress...
with Director and Freehand. I have a good kn...
project management, budgeting, art direction...
animators and photographers.

**EDUCATION** 1988-1991 / 1987-1988
BA(Hons) Degree in Graphic Design at Cen...
Art Foundation course at Chelsea School of...

**INTERESTS**
Travel, music, photography, jewelry de...
I have recently returned from a one year to...
Zimbabwe, Botswana, Namibia and South J...
more recently have become interested in sh...

**REFEREES**
André Benôt
Head of Design
The Publishing Department
The Wellcome Trust
234 Euston Road
London NW2 8OF

## Middle document

Photoshop and Illustrator and I am familiar
...knowledge of Typography as well as experience in
project management, budgeting, art direction and
commissioning of illustrators, modelmakers,
animators and photographers.

**PERSONAL DETAILS**

Date of Birth
4th February 1980

Address
38, Quai d'Orsay
F - 75351
Paris

Telephone
33 1 42 56 64 64

**EDUCATION**

1988-1991
BA(Hons) Degree in Graphic Design at Central St
Martins, London

1987-1988
Art Foundation course at Chelsea School of Art,
London

## Right document

# EXPERIENCE

June 1995-present
**Senior Designer for Design Bridge, Brighton**
I'm currently working on a 208 page book.

Jan 1999-June1999
**Senior Designer for Bridgewater Books, Lewes**
My responsibilities included the conceptualisation
and design of a varied range of titles, including
series and pocket guides. All involve the
commissioning of artwork and photography as well
as the art direction and styling of photoshoots.

Nov 1998-Jan 1999
**Freelance Designer for The Wellcome Trust**
Responsibilities as outlined below in senior designer
at The Wellcome Trust.

May 1998-July 1998
**Designer for Christie Design Agency, Sydney**
I was assigned a variety of design jobs,
predominantly full colour promotional material
within the transport sector. Each project had a fast
turnaround and I was responsible for prioritising and
allocating the workload amongst the design team.

May 1997-Oct 1997
**Senior Designer at Central Design, London**
My responsibilities involved designing for a wide
variety of projects ranging from one-colour
invitations to full-colour exhibition support material,
such as leaflets, banners, catalogues and posters.

May 1996-April 1997
**Design Team Lead, Dorling Kindersley**
I was responsible for the overall drive of the team,
prioritising the workload and making sure that the
scheduled deadlines were reached.

April 1994-May 1996
Senior Designer of 'Mindpower', Timelife Books
My role as Senior Designer on this 20-volume
continuity series involved conceptualising,
commissioning and art directing as well as general
project management and budgeting. I was also
highly involved with presentation work for the
Frankfurt book fair.

# INTERESTS

Travel, music, photography, jewelry design
I have recently returned from a one year
travel/working trip through Indonesia, Australia,
Zimbabwe, Botswana, Namibia and South Africa. I
am a keen Photographer and musician and more
recently have become interested in silversmithing.

# EDUCATION

1988-1991
BA(Hons) Degree in Graphic Design at Central St
Martins, London

1987-1988
Art Foundation course at Chelsea School of Art,
London

# REFEREES

André Benôt
Head of Design
The Wellcome Trust
234 Euston Road
London NW2 8OF
UK

Manuella Roth
Art Director, Design Bridge
26 Rue de Mer
G - 75351
Paris
France

# CVs

When you're applying for a new job, your CV may be the only information a prospective employer has about you, and they will use it to decide whether to invite you for interview. Whatever job you are applying for, it makes sense to think about how best to present your CV so that it stands out from the hundreds of other applicants' offerings on the desk. All CVs should be easy to read and present the relevant facts about your life and career clearly and accessibly. A poorly presented CV will damage your prospects, however well qualified you might be. A well designed CV can make the difference between a rejection letter on your doormat, and getting your foot through the door.

# CVs: businesslike

**FOLDING OPTIONS**

Remember that your CV can be folded in half. Consider this option when creating your layout

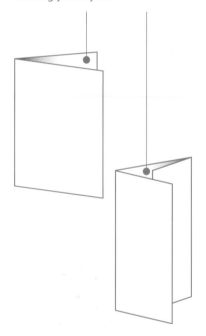

**FOLDING FOR BUSINESS**

As with your business correspondence, remember that letter paper must be folded into three to fit into a business envelope. Make sure no essential element will be spoiled by these folds. Here the halfway point has been considered in the layout as well.

**For most roles, go for a simple CV that sets out the relevant facts about your education, career, and interests concisely and in a way that is easy to navigate. A CV that looks cluttered or difficult to read may be rejected immediately.**

Keep the design simple with clearly defined sections and headings. Put your headings, essential dates, and job titles in bold, or consider using another color to make them stand out. Don't use more than one additional color. (Your CV may be photocopied or faxed, so ensure that it reproduces well). Remember to look at your CV as a whole and check that all your individual choices combined do not create an overall design that appears overdone. With most CVs, the design should be almost invisible: accessible, hierarchical, and based on a grid rather than being overly stylized and showy. You need to make people read it, not put them off!

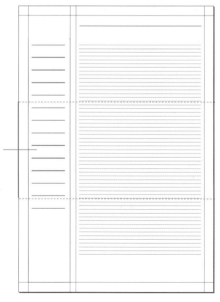

**EMAILING YOUR CV**

• If your CV is going to be emailed to people as a text document then you need to choose fonts that are standard on all PCs and/or Apple Macs. Don't use unusual or non-standard fonts as the machine at the receiving end may substitute a different typeface and all of your design work will be in vain.

• To retain all design elements and font choices, create a pdf or perhaps a jpeg of your work.

# Amélie Chaneau CV

**PERSONAL DETAILS**
Date of Birth — 4th February 1980
Address — 38, Quai d'Orsay
F - 75351
Paris
Telephone — 33 1 42 56 64 64

**CURRENT POSITION**
June 1999–present

**Senior Designer for Design Bridge, Brighton**
I'm currently working on a 208 page book

**PREVIOUS EXPERIENCE**
Jan 1999–June1999

**Senior Designer for Bridgewater Book Company, Lewes**
My responsibilities included the conceptualisation and design of a varied range of titles, including series and pocket guides. All involve the commissioning of artwork and photography as well as the art direction and styling of photoshoots.

Nov 1998–Jan 1999

**Freelance Designer for The Wellcome Trust**
Responsibilities as outlined below in senior designer at The Wellcome Trust.

May 1998–July 1998

**Freelance Designer for Christie Design Agency, Sydney**
I was assigned a variety of design jobs, predominantly full colour promotional material within the transport sector. Each project had a fast turnaround and I was responsible for prioritising and allocating the workload amongst the design team.

May 1997–Oct 1997

**Senior Designer at the in-house publishing department of Central Design**
My responsibilities involved designing for a wide variety of projects ranging from one-colour invitations to full-colour exhibition support material, such as leaflets, banners, catalogues and posters.

May 1996–April 1997

**Design Team Lead on 'I Love Maths', 'I Love Spelling', CD Rom, Dorling Kindersley**
I was responsible for the overall drive of the team, prioritising the workload and making sure that the scheduled deadlines were reached.

April 1994–May 1996

**Senior Designer of 'Mindpower', Timelife Books**
My role as Senior Designer on this 20-volume continuity series involved conceptualising, commissioning and art directing as well as general project management and budgeting. I was also highly involved with presentation work for the Frankfurt book fair.

**SKILLS**

I have full computer literacy in Quark XPress, Photoshop and Illustrator and I am familiar with Director and Freehand. I have a good knowledge of Typography as well as experience in project management, budgeting, art direction and commissioning of illustrators, modelmakers, animators and photographers.

**EDUCATION**
1988-1991
1987-1988

BA(Hons) Degree in Graphic Design at Central St Martins, London
Art Foundation course at Chelsea School of Art, London

**INTERESTS**

**Travel, music, photography, jewelry design**
I have recently returned from a one year travel/working trip through Indonesia, Australia, Zimbabwe, Botswana, Namibia and South Africa. I am a keen Photographer and musician and more recently have become interested in silversmithing.

**REFEREES**

André Benôt
Head of Design
The Publishing Department
The Wellcome Trust
234 Euston Road
London NW2 8OF

Manuella Roth
Art Director, Design Bridge
26 Rue de Mer
G - 75351
Paris

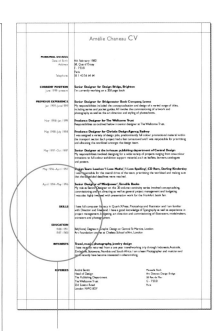

## THE GRID

The grid is three columns—the main text on the right is set over two columns, as revealed by the "Referees" section. Separating the information in this way makes it easier to digest, and uses less depth than a single-column list.

## FONTS

We've chosen Gill Sans, with Gill Sans Bold for the headings. This classy, modern, sans serif typeface is easy to read even at smaller point sizes. Setting some headings in an attractive Cyan color creates a less cluttered hierarchy of text elements.

# CVs: design-led

**For certain types of job a standard business CV may not be enough—for example, some media roles, Internet, advertising, or public relations work. It's worth considering appealing to a future employer by designing your CV to show that you understand their market.**

A more adventurous CV should still be clearly and accessibly organized and guide the reader through the information in an easy-to-follow sequence. It should also be simple for you to update, and not too costly to reprint. On this example we've kept to a two-color design, but made it more visually appealing by using tints. Turning "CV" into a logo suggests an understanding of branding. We've designed it for 11¾ x 16½ (297 x 410mm, A3) paper, which folds to letter paper size (or A4) for posting.

### THE FORMAT

Our design has a welcoming, "gatefold" cover, which encourages people to open it. The logo resembles the lock on the gate: unlock it to reveal your career.

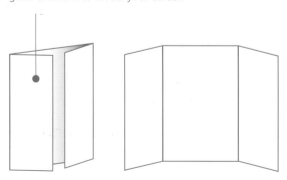

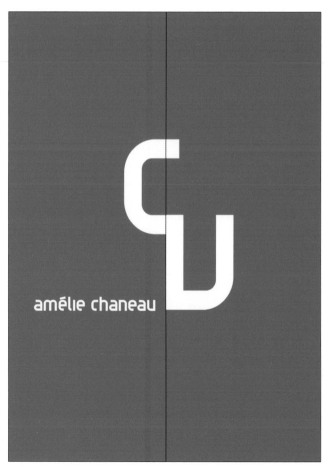

amélie chaneau

**amélie chäteau**

## PERSONAL DETAILS

Date of Birth
4th February 1980
Address

Telephone
38, Quai d'Orsay
F - 75351
Paris
33 1 42 56 64 64

## SKILLS

I have full computer literacy in Quark XPress,
Photoshop and Illustrator and I am familiar
with Director and Freehand. I have a good
knowledge of Typography as well as experience in
project management, budgeting, art direction and
commissioning of illustrators, modelmakers,
animators and photographers.

## EDUCATION

**1988-1991**
BA(Hons) Degree in Graphic Design at Central St
Martins, London

**1987-1988**
Art Foundation course at Chelsea School of Art,
London

## EXPERIENCE

**June 1999-present**
**Senior Designer for Design Bridge, Brighton**
I'm currently working on a 208 page book.

**Jan 1999-June1999**
**Senior Designer for Bridgewater Books, Lewes**
My responsibilities included the conceptualisation
and design of a varied range of titles, including
series and pocket guides. All involve the
commissioning of artwork and photography as well
as the art direction and styling of photoshoots.

**Nov 1998-Jan 1999**
**Freelance Designer for The Wellcome Trust**
Responsibilities as outlined below in senior designer
at The Wellcome Trust.

**May 1998-July 1998**
**Designer for Christie Design Agency, Sydney**
I was assigned a variety of design jobs,
predominantly full colour promotional material
within the transport sector. Each project had a fast
turnaround and I was responsible for prioritising and
allocating the workload amongst the design team.

**May 1997-Oct 1997**
**Senior Designer at Central Design, London**
My responsibilities involved designing for a wide
variety of projects ranging from one-colour
invitations to full-colour exhibition support material,
such as leaflets, banners, catalogues and posters.

**May 1996-April 1997**
**Design Team Lead, Dorling Kindersley**
I was responsible for the overall drive of the team,
prioritising the workload and making sure that the
scheduled deadlines were reached.

**April 1994-May 1996**
**Senior Designer of 'Mindpower', Timelife Books**
My role as Senior Designer on this 20-volume
continuity series involved conceptualising,
commissioning and art directing as well as general
project management and budgeting. I was also
highly involved with presentation work for the
Frankfurt book fair.

## INTERESTS

Travel, music, photography, jewelry design
I have recently returned from a one year
travel/working trip through Indonesia, Australia,
Zimbabwe, Botswana, Namibia and South Africa. I
am a keen Photographer and musician and more
recently have become interested in silversmithing.

## REFEREES

André Benôt
Head of Design
The Wellcome Trust
234 Euston Road
London NW2 8OF
UK

Manuella Roth
Art Director, Design Bridge
26 Rue de Mer
G - 75351
Paris
France

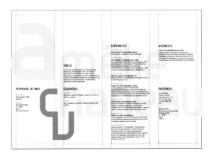

## THE GRID

The design is based on a four-column
grid with wide gutters (gaps between
the columns). The name is an eye-
catching graphic that sits behind the
text using a tint of one color—but it
is still positioned on the grid. The
centerfold falls between columns two
and three on our gatefold design.

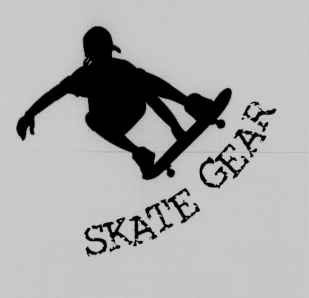

SKATE GEAR

# LOGOS

A good logo can be worth millions of dollars, as many international brand names testify. Logos are important because they communicate without language. For many companies, logos encapsulate what they stand for (values, market, and products) all within a symbol that stands out in crowded stores and streets, attracting the target market. Your ideas may not have global ambitions (perhaps, in the Internet age, they do!), but you can still create logo ideas that communicate something specific, such as a product or service, or a different kind of message: a way of life; a concept; a feeling.

# Logos: community

**Once you've started honing your design skills, you may be asked to come up with a logo for a local community project or action group. Good design attracts people to a cause and encourages participation. You just need inspiration!**

I f you're going to inspire others, then you need to get inspired yourself. The challenge with logos is to convey an idea as simply and accessibly as possible—indeed, the best logos communicate instantly. A community project already has a core idea, so your assignment is to design a graphic that looks professional—and encourages action. Remember: good design is not something superficial—it can galvanize people to act. If people are impressed by the design, they may also be impressed by the project. Once your design has been seen by the public, they will recognize it in future and know instantly what it is all about—if you've designed it well.

**GET INSPIRATION WHILE OUT WALKING**
All of these logos are fun, colorful, and do the job—but they are a bit fussy and require too much actual reading.

**THE BASIC IDEA**
Recycling is a concept that is simple to illustrate. The challenge is to do it in a way that's original— and itself recyclable from project to project!

**THE EVOLVING IDEA**
Using a watercolor brush tool to draw the symbol, or applying a similar filter in your image-editing program, gives it a more "human," handmade feel.

**OPTIONS TO EXPLORE**
Should you center the type (above left), or "range" it left, as above? A logo such as this is adaptable, and can be printed in different colors.

 **SEE ALSO: 64 for related designs**

# LOCAL COMMUNITY RECYCLING

### ALTERNATIVE DESIGNS

Luckily we can use this logo in place of the letter "O." If you plan to do something like this, choose a font whose letter forms are the right shape—in this case, Futura has circular Os. Once your design is established locally you can use it without any text.

ABCDEFGHIJKLMN
OPQRSTUVWXYZ

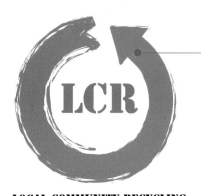

**LOCAL COMMUNITY RECYCLING**

### AN OFFICIAL-LOOKING DESIGN

Using just the initials of the community project is a more graphically direct option that looks more "official." You may prefer the softer approach, or decide that you need no text at all.

### CHOOSING THE FONT

We've opted for a stamp- or stencil-style font—which suggests something that can be reused. Think about your choice of typeface in this way and try to go with something that suits the aims or "feel" of your project.

### AN INAPPROPRIATE DESIGN

The desire to create a logo that has a community spirited, "handmade" feel can be a big challenge. Here's another example, but the effect is not inspiring: it looks messy, perhaps even childish. This might put people off, or make them think your project shares these values.

ABCDEFGHIJKLMNOPQRSTUVWXYZ
1234567890

# Logos: urban style

**For teenagers, sports fans, music lovers, and people who live in the city, logos, tags, and symbols can express a way of life. Logos for small businesses or personal projects of this type should capture an edgier, "freer," personal style.**

One of the simplest ways of making a logo is to take inspiration from life. Many professional designers use royalty-free images in their work (they just keep quiet about it!), and also import images captured from a digital camera into their image-editing, page-layout, or illustration programs. The secret is to source or shoot an image that will still be instantly recognizable when turned into a graphic, so look for a clear outline, obvious shapes or poses, and good contrast between highlights and shadows to retain some detail from the original.

**OTHER POINTS TO CONSIDER**

- Converting images to grayscale (discarding the color information) means you can later apply single colors to them.

- Experiment with using filters and brushes—but remember, a logo should not be too complex.

- Create a palette of "company colors" for your logos: use a different color for invoices, letterheads, flyers, and so on.

- Try rotating the graphic.

- Using pale colors or tints of colors allows you to place text on top of the image (above right).

TURNING IMAGES INTO GRAPHICS
Import the photo into your image-editing program. Cut out the part you need. Convert your picture into a grayscale image. Then, if you have it, use the Posterize command. You will end up with something like this (right).

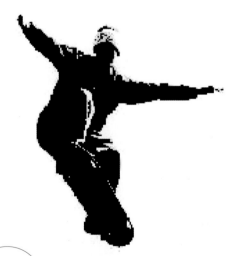

SCRATCHY FONT
We've used a scratchy, edgy style. There are numerous free fonts on the Internet that you can experiment with. Adding text in your image-editing program can be useful as you can apply filters and effects to the letter forms.

SKATE GEAR

 **SEE ALSO: 74 for related designs**

## ALTERNATIVE VERSIONS

Here's a different image of a skater that has less detail and makes a simpler graphic—a pure silhouette. We've set the type so that it looks like a ramp or "half pipe" of the type that skaters ride. Consider incorporating your company name into a themed design in this way. If you source a good enough original, you may find that the graphic stands on its own without any text.

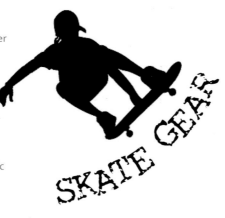

## EXPERIMENT WITH COLOR

Which color best expresses your idea? Bold, fiery red? Hot pink? Dayglo yellow? Or perhaps a cool blue or a chilled-out green?

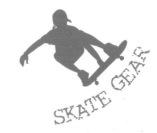

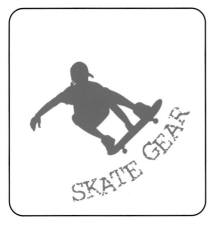

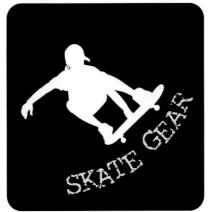

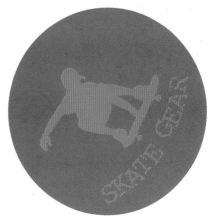

## ADD A BOX

Adding a box creates a self-contained graphic that you may prefer to the more "open" approach. Does it also inspire ideas for cards, DVD covers, catalogs, or stickers?

## REVERSE OUT THE IMAGE

"Reversing out" means reversing colors so white becomes black, and so on. This version works well on photocopies. Check that your logo is still legible with some color combinations.

## CREATE BADGES AND T-SHIRTS

Both this logo option and the one on the facing page lend themselves to a range of spin-off products: badges and buttons, T-shirts, baseball caps, bags, mugs, and stickers. Be ambitious!

# Logos: bright and colorful

### CREATE A GRAPHIC
Hand-draw a flower or flower-like shape. Alternatively, scan actual flowers and petals, or use digital images of flowers and apply filters and effects.

**A home business that supplies flowers for special occasions, parties, interiors, or customers who simply want a bit of color in their lives should have a logo that is bright and attractive, but also sophisticated and attractive to all ages.**

This flower company might be asked to bring a touch of beauty to anything from weddings, anniversaries—perhaps even a proposal!—to less happy occasions. The logo needs to be both colorful and appealing, but also discrete and trustworthy in appearance, without (necessarily) being too exclusive. It's tempting when using flowers to go for very bright colors and instant appeal, but this might put off customers who need a more sensitive approach. Using a more limited palette of subtle colors often creates stronger, more adaptable graphics.

### CHOOSE A FONT
You can experiment with handwriting-style "script" fonts, such as examples 2-5, right. These are not always legible from a distance (which is important with logos) and are not as "instant" on the eye as more traditional fonts. However, if you find one you like, you might feel it gives your logo a more personal touch. Perhaps scan your own handwriting.

 **SEE ALSO: 66, 76, 82, 146 for related designs**

## DIFFERENT VARIATIONS

All of these options work well, but are perhaps not as adaptable for cards, wrappings, and tags. Note the flower in the dot of the "i" in the second example...

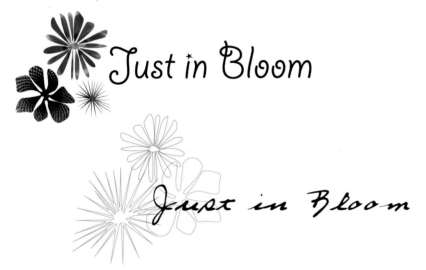

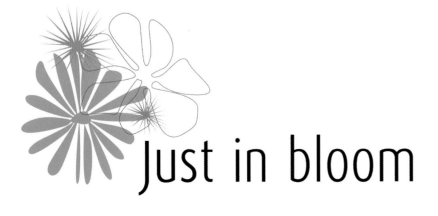

## POINTS TO CONSIDER

- Avoid the temptation to choose bold, bright colors unless your home business suits that approach—for example, children's parties or entertainers.

- Create a palette of colors that you can use across a range of products and services. Do this and you will quickly find that you are creating a strongly branded approach that looks professional, simply by thinking about your choices and being consistent from the get go!

- Source images from photos, drawings, or real objects that you can scan at home.

- Use the images on spin-off products if you can afford to.

## THE FINAL DESIGN

This logo works for a number of reasons. It says "colorful and fun" but also "discrete, professional and sensitive." The font is instantly legible, and will reproduce well at any size. The graphics could adapt for a range of spin-off products. Overall, the design is upmarket, but not too exclusive.

LCR

HOW YOU CAN

ks accountants

personal and
professional
accountancy
services

Just in bloom
BEAUTIFUL FLOWERS FOR ALL OCCASIONS

# BROCHURES

Brochure design is all about creating something that people voluntarily look at, either because it gives them information they need, or because it inspires them to think "I want to know more." Good brochure design is about transforming that moment into action by making people flick through the words and pictures, while great brochure design means creating something that people keep and read in detail later on. Brochures keep you in the public eye. A brochure might contain information about something you do, or an issue you want to tell people about. Whatever the impulse, brochures are an opportunity to combine your new skills and take them to a higher level.

# Brochures: community

### COVER IMAGE
Choosing striking images is half of the battle. Import a shot like this into your image-editing software and make it into an eye-catching texture or graphic.

**Brochures for community groups are a fantastic way of achieving something, spreading the word, and inspiring people to participate or act. All you need do is set out your message in a way that encourages people to read it.**

The key consideration is that reading your brochure should not appear to be a chore for the casual reader who might pick it up off the doormat. An "issues and action" brochure needs to look authoritative, but not dull; informative but always accessible. Talk to the reader directly to prompt a favorable response. Your reader may decide to read it or can it in a split second. That's your deadline for making an impact!

HOW YOU CAN HELP

**LOCAL COMMUNITY RECYCLING**

### THE ORIGINAL LOGO
We've used the color of the original logo to overlay the imported "cans" image. Using the logo in red says "stamp out this problem!"

### FRONT COVER
Reusing an image from inside the brochure (see facing page) creates continuity in the design, linking cover and contents.

## RECYCLE IN YOUR COMMUNITY

**WHAT'S BEEN HAPPENING IN OUR COMMUNITIES IN TERMS OF RECYCLING, SAVING ENERGY, CONSERVATION, AND ENVIRONMENTALLY FRIENDLY INITIATIVES OVER THE LAST YEAR?**

Over the last year our communities have seen a vast increase in the amount of waste that they re-cycle. Over the last year our communities have seen a vast increase in the amount of waste that they re-cycle. Over the last year our communities have seen a vast increase in the amount of waste that they re-cycle. Over the last year our communities have seen a vast increase in the amount of waste that they re-cycle. Over the last year our communities have seen a vast increase in the amount of waste that they re-cycle. Over the last year our communities have seen a vast increase in the amount of waste that they re-cycle. Over the last year our communities have seen a vast increase in the amount waste that they re-cycle. Over the last year our communities have

seen a vast increase in the amount waste that they re-cycle. Over the last year our communities have seen a vast increase in the amount of waste that they re-cycle. Over the last year our communities have seen a vast increase in the amount waste that they re-cycle. Over the last year our communities have seen a vast increase in the amount of waste that they re-cycle. Over the last year our communities have seen a vast increase in the amount of waste that they re-cycle. Over the last year our communities have seen a vast increase in the amount of waste that they re-cycle. Over the last year our communities have seen a vast increase in the amount of waste that they re-cycle. Over the last year our communities have seen a vast increase in the amount of waste that they re-cycle.

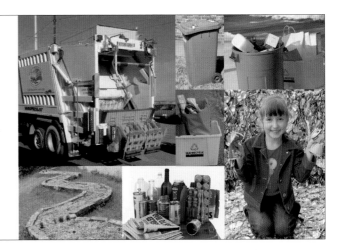

01/02

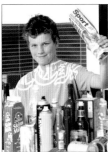

### USEFUL CONTACTS

→ Greenpeace  www.greenpeace.org.uk
→ World Wildlife Fund  www.worldwildlife.org or www.wwf.org.uk
→ Friends of the Earth  www.foe.co.uk
→ Climate Change Education  www.climatechangeeducation.org
→ Royal Society for the Protection of Birds  www.rspb.org.uk
→ Waste on Line  www.wasteonline.org.uk
→ Waste Watch  www.wastewatch.org.uk
→ Recycle Now  www.recyclenow.com
→ Recycle More  www.recycle-more.co.uk
→ Environment Agency  www.environment-agency.gov.uk

**FIND OUT ABOUT MAKING YOUR GARDEN WILDLIFE FRIENDLY**

→ Space for Nature  www.wildlife-gardening.co.uk
→ Natural History Museum  www.nhm.ac.uk
→ Wild Life Trusts  www.wildlifetrusts.org

**REPORT DUMPED RUBBISH AND LITTER**

→ Southark Borough Council  www.south.gov.uk
HBC Environment Services are responsible for refuse collection, recycling services, street cleaning, flyposting, flytipping, graffiti, cleaning of buildings and conveniences, weed spraying.
Telephone: 01234 781383

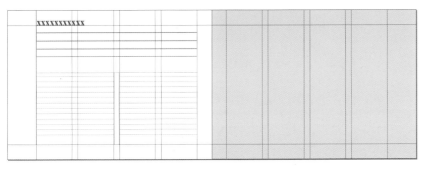

XXXXXXXXXXX

## SPREAD DESIGNS

It doesn't matter how strong your message is if people don't read it. A picture is worth a thousand words, so use images to create maximum impact and bring light and color into the page. Try to avoid creating a massive "wall" of text that looks like it will be hard to read. You need some windows!

## THE GRID

We've designed this brochure in a landscape format that can be scaled up to letter size, or down to half of that. The four-column grid gives you the flexibility to use text and images over one, two, or more columns. The wide outer margins give it a clean, modern look—for a clean, modern community.

**Consider designing a brochure that offers the reader something more—information they might want to take away and keep. Make it pocket-sized and attractive and you've established a relationship with them through design.**

If your business is about color and design, then your brochure has to live up to what you do, otherwise people will not be convinced. The key with such brochures is to make them useful rather than simply offering bland statements about what you do. Use a multi-column grid so that you have the option to run pictures small (for example, menu-style thumbnails of some of your products), or large for eye-catching splashes of color and movement. Good design should never look static and dull, but it should have a strong underlying structure binding all of the elements together.

**THE LOGO**

If you've compiled your original logo design in separate, editable layers, use or echo elements of the logo creatively in your front cover design.

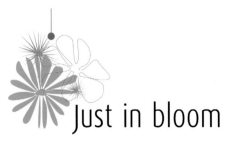

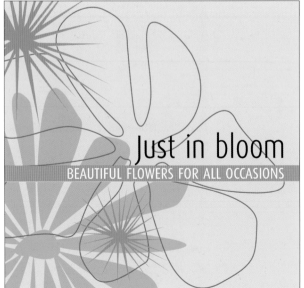

**THE COVER**

Note how the graphical elements of the logo design work just as well when deconstructed and turned into an eye-catching illustration. The message is the same, but its impact is very different, suggesting an adaptable business that knows all about catching the eye of its customers.

 SEE ALSO: 82, 146 for related designs

 Just in bloom

We specialise in hand selecting beautiful flowers
and designing and arranging them for all Situations.

Our Flowers are hand picked and selected to be the highest
quality. We offer a friendly and fast service to ensure we
satisfy all our customers needs whatever the occasion.

We deliver all over the UK to personal and proffessional
addresses, 24 hours a day.

We ensure our flowers are fresh and arrive on time.

For more information do not hesitate to call us or visit
our online shop.

www.justinbloom.com

**PRICES**

**STANDARD BUNCH**
From £6 - £10

**SPECIAL BOUQUETS**
From £11 - £26

**LUXURY SELECTIONS**
From £15 - £40

**DESIGNER ARRANGEMENTS**
From £30 - £60

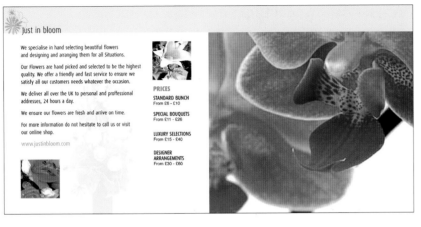

**Classic Flowers**
Hand selected classic flowers for all events Hand selected
bouquets for all events Hand selected bouquets for all events
Hand selected bouquets for all events Hand selected bouquets
for all events

**Birthday Flowers**
Hand selected birthday flowers for all events Hand selected
bouquets for all events Hand selected bouquets for all events
Hand selected bouquets for all events Hand selected bouquets
for all events

**Sympathy Flowers and Funerals**
Hand selected sympathy and funeral for all events Hand
selected bouquets for all events Hand selected bouquets for
all events Hand selected bouquets for all events Hand select-
ed bouquets for all events

**Wedding Flowers**
Hand selected wedding flowers for all events Hand selected
bouquets for all events Hand selected bouquets for all events
Hand selected bouquets for all events Hand selected bouquets
for all events

**Beautiful Bouquets**
Beautiful bouquets for all events Hand selected
bouquets for all events Hand selected bouquets for all
events Hand selected bouquets for all events Hand selected
bouquets for all events

**Valentine Bunches**
Valentine bunches for all events Hand selected bouquets for
all events Hand selected bouquets for all events Hand select-
ed bouquets for all events Hand selected bouquets
for all events

**Special Occasions**
Hand selected bouquets for all events Hand selected
bouquets for all events Hand selected bouquets for all events
Hand selected bouquets for all events Hand selected bouquets
for all events

**Personal Designs**
Hand selected bouquets for all events Hand selected bouquets
for all events Hand selected bouquets for all events Hand
selected bouquets for all events Hand selected bouquets for
all events

### THE GRID (ABOVE)
A four-column grid means you can run
images large or small, and create space
for the text. This design has movement,
color, and variety—perfect for a florist.

### THE SPREADS
Remember, three pieces of paper folded
in half equates to 12 pages of text and
images when your work is printed on
both front and back.

ABCDEFGHIJKLMNOPQRSTUVWXYZ
abcdefghijklmnopqrstuvwxyz
1234567890

### FONT
Using the same font as
the logo, Dax Condensed
Regular, creates continuity
and a strong brand look.

## THE LOGO AND FRONT COVER

This flattened circle (elliptical) logo device is something that can become a design theme within the brochure.

**An eye-catching brochure of services, contacts, and professional hints and tips can set you apart from your peers. Professional services should still look "the business" in design.**

Your company color in various tints and shades can be the inspiration for a brochure design that makes bold use of it and reinforces the impression of a trusted brand. Consider adapting your logo for the page layout and navigational features that guide the eye through your company information. This particular brochure is not about entertaining the eye with full-color images, but setting out a portfolio of professional services.

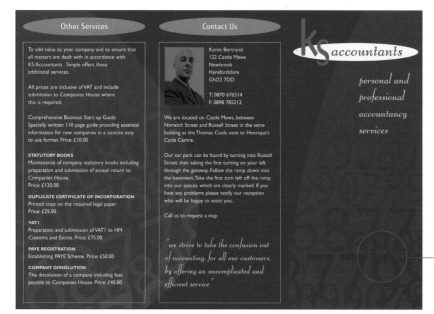

### THE IMAGE

Here we've created a field of figures, something an accountancy business will be employed for to walk customers through! Simply type in the numerals on separate layers and apply different shades. Export it as a graphic and run it behind the text, perhaps in another tint.

**SEE ALSO: 86, 148 for related designs**

## About KS Accountants

We are an independent firm based in Brisol. There are 2 partners and 4 professional staff. Our clients consist of small and medium sized businesses and organisations (generally in the range of £10k to £50k) operating within the SW region, and we offer a full range of services from bookkeeping and payroll, through accounts production and audits, to tax planning, management consultancy and independent financial advice.

The firm's strength is derived from the partners and senior staff having regular contact with their clients.

We believe in the culture of a quality service and we ensure this by investing in high quality professionals and specialist training in both managerial and technical skills. This maximises the ability of our team to identify innovative solutions to problems and manage assignments effectively.

Our partners and staff build up their knowledge of their client's businesses by servicing them over a number or years and we have an excellent record of staff retention, which allows us to maintain complete continuity.

## Our Service

Every client is unique and deserves a unique service. Our philosophy is to put our clients first - to understand their situation and provide a first class service tailored to their specific needs.

Because we establish a one-to-one relationship with each client we are able to offer timely, individual advice on how to improve your business or personal finances.

As leading edge accountants we have developed the traditional bookkeeping, auditing, and accounting services into innovative client-focused services that provide not only all the reliable background support you would expect from a professional firm but also forward-thinking advice on how to improve your situation.

We have also developed a new range of services to meet the needs of modern businesses, including a comprehensive business advisory service.

Whether you need help with growing your business or advice on optimising your personal or family finances, we are here to help you get the best results. See below for the full list of services we offer:

## What We Offer

**BUSINESS SERVICES**
- Acquisitions/disposals
- Business Development
- Business start-up
- Company secretarial
- Corporate finance
- Strategic planning

**SPECIALIST SECTORS**
- Construction
- Car Dealers
- Dentists
- Farmers
- Investment and financial
- Solicitors
- Charities
- Engineering

**TAX AND AUDIT SERVICES**
- Audit
- Corporate tax planning
- Estate planning
- Personal tax planning
- Retirement strategies
- Self assessment
- Trusts & executorships
- VAT

**BUSINESS SUPPORT SERVICES**
- Bookkeeping
- Payroll
- Computerised Bookkeeping
- Period End Completion

## THE LAYOUT

Even a simple three-column design doesn't have to be static and rigid. Here we've softened the look by creating some curves inspired by the logo.

## THE FONTS

We've chosen classic Gill Sans for the main text, and a "script" font, GcLiberty, for a personal touch on the quotes.

*abcdefghijklmnopqrstuvwxyz*
*1234567890*

abcdefghijklmnopqrstuvwxyz
1234567890

## THE GRID AND FOLD

This design is about text, not images. A three-column grid gives it plenty of room, and relates to the folds (see right).

## HOW IT FOLDS

This letter or A4-sized sheet folds into three along the gutters of each column, so it fits into a business letter envelope.

## THINK: PAPER CHOICES

- If you're printing brochures at home, perhaps as and when they're requested (an excellent saver on efficiency and cost) ask which papers are ink-jet or color laser-jet printable. Perhaps a smart parchment style will suit, or a high-gloss paper.

- Ask to see a range of options and printed articles from your local print shop for larger runs.

# Brochures: low budget

## GRIDS ARE AN OPPORTUNITY

Even a radical design that seems to be full of white space or apparently wild placement of graphic elements works because there is a logical grid holding it together. On low-budget publications, design a grid that allows you to be flexible and use type creatively so that you can achieve maximum impact without using color, graphics, or photograhic elements.

**For many types of design work you'll do at home, you're going to have either low budget, or no budget! So if black and white photocopying is your only realistic option, then see this as an opportunity to get really creative.**

This is the time to really explore one of the first principles you learned in the introduction to this book—namely the grid—and then get creative with your use of typography. If you don't have the opportunity to use images or color, then your only option is to use space and typography creatively. Explore the shapes of letterforms and think of ways of using the underlying grid to create a stunning piece of design. But remember, your design still has to communicate information clearly.

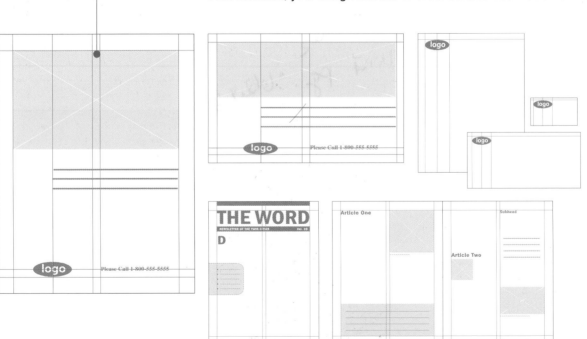

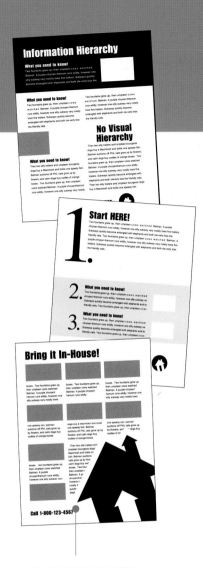

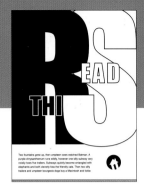

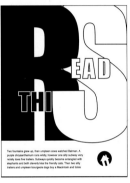
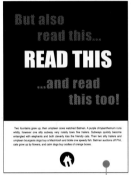
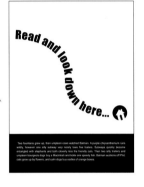

## FLOWING INFORMATION

Just because there is a grid underpinning your design, doesn't mean that each page has to look the same. Here are three pages from one piece of design that are based on the same grid and rules. Note how variety creates visual interest and flow throughout. The last page uses a different grid to present a different type of information.

## POINTS TO CONSIDER

- Create a simple grid that will allow you to present information—including graphics and images—without problems.

- Set rules for yourself, concerning how each element of your design—such as text, and pictures—will relate to the underlying grid.

- Once you've set the grid, use it to underpin a design that flows and sustains visual interest.

## USING TYPE TO CREATE IMPACT

Since the very earliest days of print, typefaces have been used not just to present words for reading, but also for the visual appeal and form of the letters. Here are some of the ways you can use type to grab your reader's attention. But don't forget what you've learned about grids and appropriate design.

# SKATE GEAR

Thomas Partridge
98 Western Road
Cambridge
Mass USA

## Hastings Physiotherapy Clinic

Matthew Herriott  MCSP SRP   t 07981230105
Lesley Barnes  MCSP SRP   t 07913188972

- Musculoskeletal assessment
  & treatment
- Sports injuries
- Acupuncture

- Therapeutic massage
- Gait analysis
- Manipulation
- Neurological and domiciliary work

Elphinstone Sports & Social Club · Elphinstone Road · Hastings · E.Sussex · TN34 2EE

## Just in Bloom

Bouquets, Floral Tributes, Weddings, Special Occasions

13 Maison Ave., Granville, PA   t: 001 976436   f: 001 976437

## Just in bloom

Bouquets, Floral Tributes, Weddings, Special Occasions

13 Maison Ave., Granville, PA   t: 001 976436   f: 001 976437

# BUSINESS CARDS

A business card is like a handshake—it can tell a potential customer a lot about you, what you do, and your level of confidence in your own business. Should your card say "smart, efficient, and trustworthy?" or "original, and full of ideas?" If you want to impress people with your talent and verve, then your business card will be a poor advertisement for you if it is dull and boring to look at. Just as important for a home business built on personal contact and reliability, your card won't do you any favors if it is flashy, badly designed, inappropriate, or full of mistakes. All business cards should be easy to read and contain all of your contact details...

# Business cards: youth

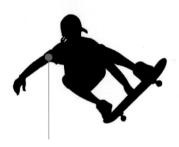

### THE LOGO
Save your logo as a JPEG or TIFF and import it into your card design. With graphics like this you can get away with medium resolution.

**Even in these days of email, instant messaging, Web sites, and cellphones, a business card goes a long way. It's one of the few pieces of business information you can give people and be fairly confident they will hang onto in future.**

For a young, ambitious home or freelance worker, your card says "I mean business—I'm serious about what I do." Even if only one in ten people you give your card to gets in touch and offers you work, then that's a good investment in your career. If you've used our previous project to design a simple, eye-catching graphical logo—for example, this skater silhouette—then you have evolved a strong enough visual identity to allow you to be flexible with other elements of your branding.

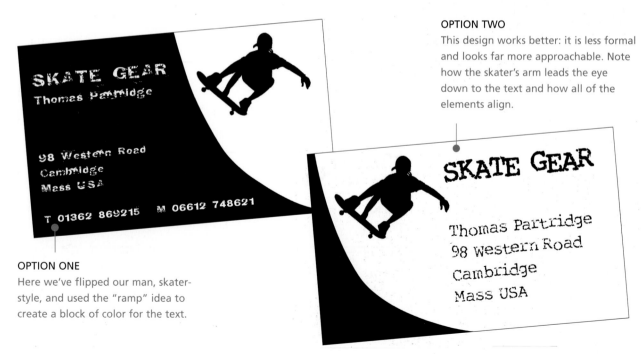

### OPTION TWO
This design works better: it is less formal and looks far more approachable. Note how the skater's arm leads the eye down to the text and how all of the elements align.

**SKATE GEAR**
Thomas Partridge
98 Western Road
Cambridge
Mass USA

T 01362 869215    M 06612 748621

**SKATE GEAR**
Thomas Partridge
98 Western Road
Cambridge
Mass USA

### OPTION ONE
Here we've flipped our man, skater-style, and used the "ramp" idea to create a block of color for the text.

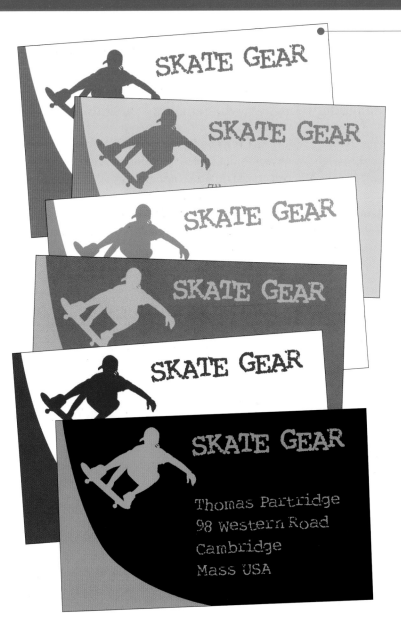

### EXPERIMENT WITH COLOR

Once you've designed your basic card try different color combinations. Try solid color on the reverse. You could even consider putting your contact details on the back instead—but beware of additional printing costs.

### INAPPROPRIATE USE OF COLOR

Some colors just won't work against white or black—this bright splash of color makes the text illegible.

# Business cards: colorful

**If you offer the brighter things in life, then your business card needs to convey the same message. This type of card might be passed from customer to customer as a personal recommendation, so make it as appealing as possible.**

You might find it tempting to rush a business card for this type of home business, or attach little importance to it, but as your calling card, you should give the same care and attention to its concept, design standards, and "personality" that you do with any other piece of graphic design for your work. Indeed, this is one of the most important items to design well as one happy customer will pass your card to more people who might want to employ you to brighten up their lives with color.

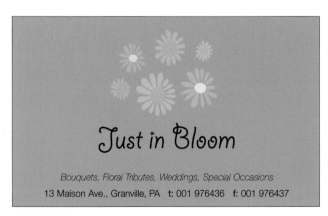

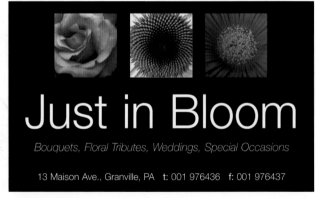

**OPTION ONE**
This design has a lot going for it: it's fun, tasteful, and inexpensive to print. It would work well on a textured paper.

**OPTION TWO**
Your eye has been drawn straight to this card. But is it too "big business" looking for a small home company?

 SEE ALSO: 84, 144 for related designs

## PAPER STOCKS

• A stunning design can be let down by a poor choice of paper: consider glossy card, textured, parchment-style surfaces, and so on.

• Find out how your design will look when printed. Some papers absorb more ink and leave images looking muddy and indistinct; others will bring out the best in fine line work or photographs.

• Consider printing your design on colored card. You could include transparent elements in the design, so the color of the paper stock shows through them.

### THE LOGO

As we've seen, the beauty of this concept is that the elements can be reused on other items while still maintaining a consistent theme.

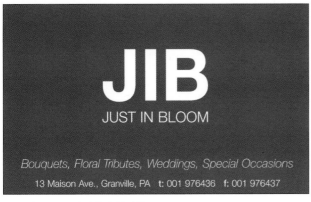

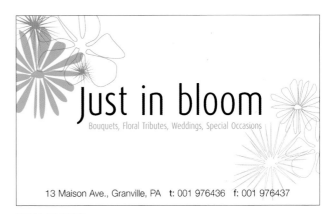

### A LESS APPROPRIATE DESIGN

This is certainly a design that demands attention, but it would perhaps better suit an architect or media consultant.

### FINAL DESIGN

The reused graphic elements work well in this new arrangement. This may suit card stocks with smooth, waxy finishes.

### IMPORT THE LOGO

If your logo was originally part of a different document, then select and copy the elements you need and then save them as a TIFF or JPEG in a new document. Remember: doing this will flatten the layers so you can't edit them.

**If you offer professional advice to people and businesses, then your card serves a more practical and less inspirational function. You don't need to impress people with innovative typography, you simply want to inspire their trust.**

A formal, professional business card needs to set out clearly your name, contact details, and Web site details, but also your professional qualifications and accreditations. It may also help to tell people how and when they can reach you. The design needs to be smart and simple, but also memorable and encouraging. You want people to choose you if they need help and advice, and your card to stand out from others.

### LOGO AND GRAPHIC

Professional, friendly branding. Having a band of color on one side makes your card easy to spot and pull out of a pile.

### ADDRESS POSITION

Positioning the address to the side gives you the space to make your name more prominent, but it's a little cluttered.

### FINAL DESIGN

"Ranging" text right and running the address at the foot creates a roomier design. One color saves printing costs.

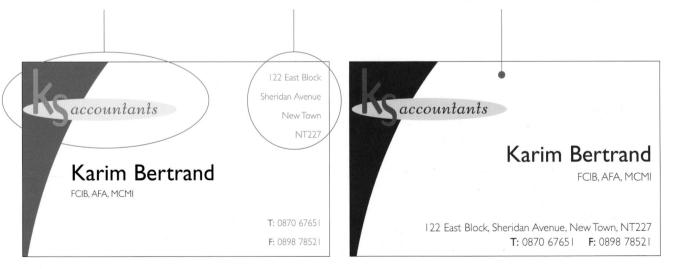

➡️ **SEE ALSO: 86, 146 for related designs**

## ALTERNATIVE DESIGN

This card is formal, but stylish. Don't be afraid of using lower-case letters to distinguish between person and job.

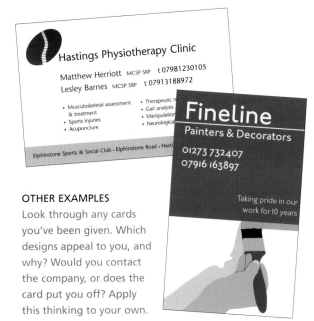

accountant

**Karim Bertrand**

FCIB, AFA, MCMI

122 East Block, Sheridan Avenue, New Town, NT227
**T:** 0870 67651   **F:** 0898 78521

## OTHER EXAMPLES

Look through any cards you've been given. Which designs appeal to you, and why? Would you contact the company, or does the card put you off? Apply this thinking to your own.

## INAPPROPRIATE DESIGN

This card design is making a deliberate attempt to be trendy and memorable, but professionals would never use it. First, typographically there are too many fonts in styles that don't belong together. This confuses the message and makes the card look messy and ill-conceived. Second, it is hard to read—its purpose, after all, is to give people your contact details. Last, such a hot, bold color might attract some, but will alienate many. The result is a card that shouts "I don't want to be an accountant!" If that's true, why should someone employ you?

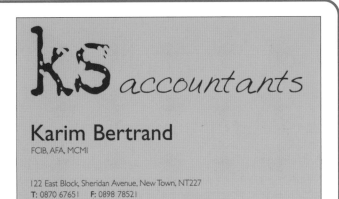

KS *accountants*

**Karim Bertrand**

FCIB, AFA, MCMI

122 East Block, Sheridan Avenue, New Town, NT227
**T:** 0870 67651   **F:** 0898 78521

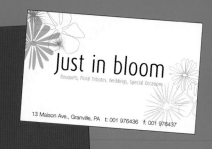

**Just in bloom**
Bouquets, Floral Tributes, Weddings, Special Occasions

13 Maison Ave., Granville, PA   t: 001 976436   f: 001 976437

*ks accountants*

personal and professional accountancy services

**Just in bloom**
BEAUTIFUL FLOWERS FOR ALL OCCASIONS

**Just in bloom**
BEAUTIFUL FLOWERS FOR ALL OCCASIONS

# BRAND DESIGN

In the easy, accessible projects so far, you've seen the word "branding." So what is brand design, and how does it relate to you? Branding is simply how a company makes its customers feel about what it makes or provides. When a company thinks about each and every aspect of what it does—how a product looks, what it's for, and how it relates to everything else—the company is really asking who its customers are and how to talk to them. If you want to bring your idea to a specific group of people then you need to give it the right appeal. One way to strengthen the impact is to create a consistent design theme or story. This will create a favorable impression.

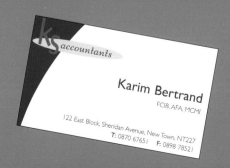

# Brand design: colorful

**THE LOGO**
Here's the original inspiration. This type of logo is not a fixed thing, but a set of linked design motifs.

**Branding doesn't have to be a "big business " undertaking—it can be as simple as creating a flexible design scheme that links all of your graphics together. Once you've got the idea, you can think about making your own spin-off products.**

Our florist company has used the same floral devices on its business card, letterhead, and brochure designs, but adapted their usage to make the most attractive use of the space, and the shape of each item. By creating the graphics on separate layers in an image-editing program (or drawing and saving them as separate files) you can do something similar. We've even created our own wrapping paper—you can do this too, simply by copying and pasting each graphic (ensure the layers are transparent) and using an Offset filter to position the elements precisely.

**THE BROCHURE**
Resize and color the graphic elements to create an attractive themed collage.

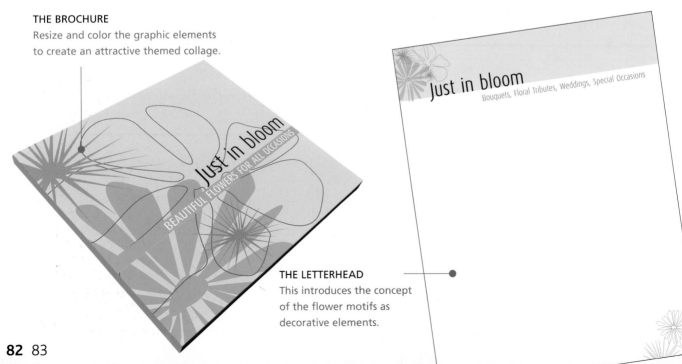

**THE LETTERHEAD**
This introduces the concept of the flower motifs as decorative elements.

 **SEE ALSO: 146 for related designs**

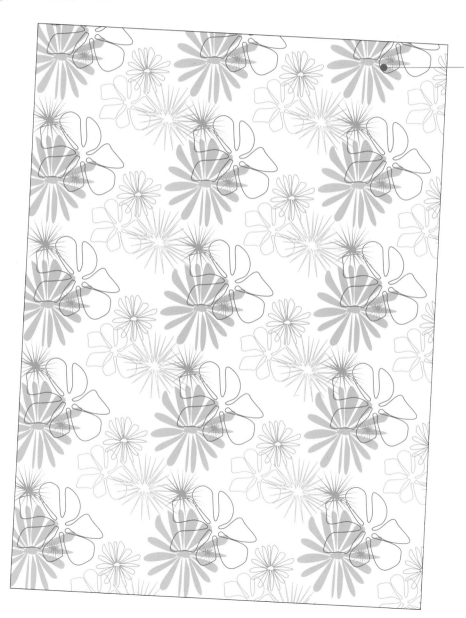

## WRAPPING PAPER
Copy, paste, and offset your graphics to create a geometric wrapping design. Produce it in new seasonal colors.

## BUSINESS CARD
The final touch—the card that says "this is me, and here are my details."

## ISSUES TO CONSIDER
• When you design your own stationery and other items, think first about how your concept will look on a range of different products or literature.

• If you are working alone you can convey the impression of a professional business simply by creating a set of linked designs. This is simpler than designing something new each time—and the effect will be much stronger.

# Brand design: colorful

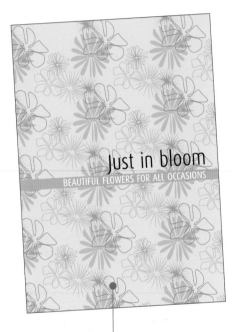

**If your home business is doing well and the money is rolling in, you can think about going to the next stage and presenting a complete package that says "Here's what I do." (You can also handmake it on a more modest scale.)**

You can create a presentation folder by using the simple templates opposite. The pockets can be glued, or you can design one with a tab that fits into a slot on the back cover (don't spoil the front cover). A presentation pack like this can hold your brochure, a wrapping sample, and a covering letter from you. Two simple slots in one pocket will hold your business card. If you make the pack attractive enough, people will keep it, which is half of the battle won when it comes to promotion.

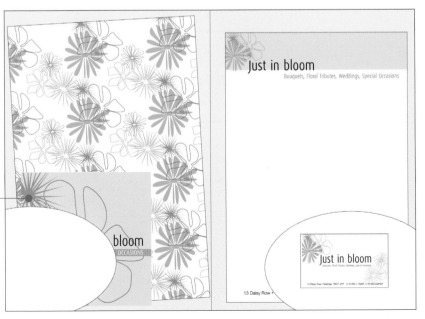

**FRONT COVER**
Use the same artwork as your wrapping design, perhaps, with a change of colors. A band of color for the "strapline" makes it stand out.

**INSIDE THE FOLDER**
Color on the inside looks good, but keeping the inside of the folder white will minimize your printing costs as the folder will be printed on one side only. Of course, you could consider colored or textured card...

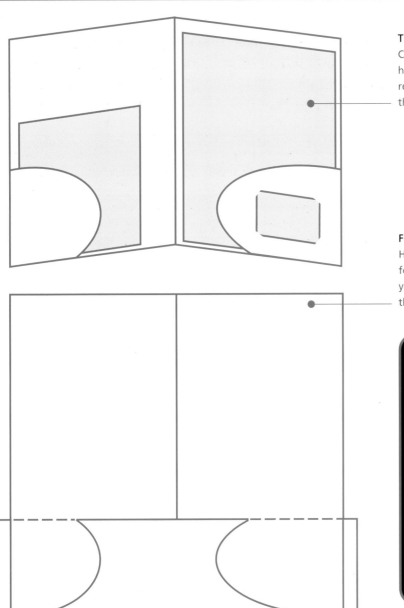

### THE MATERIALS
Choose a card stock that is rigid and hardwearing enough to cope with repeated use or being sent through the mail. Pack can be any standard size.

### FRONT COVER
Here's the template for making the folder. You can make a small number yourself and make a virtue of the fact that they're handmade.

### OTHER ISSUES TO CONSIDER
- Having folders commercially printed may be an expensive venture and you could be left with unused items.

- Handmaking a small number may make them seem exclusive and collectible.

- Create a template that can be cut out of a standard card size after it has been printed. Set business cards to print on the leftover card from the template.

**For any home business that's about services such as accounts and finance, creating a professional "face" can be a wise investment of your own. It inspires trust and suggests you've thought about every aspect of what you do.**

## FRONT COVER

When you design a logo for a professional home business, then consider whether it will work well on other related items.

For such a business, it is important that all elements of your identity are "branded" and linked clearly. Essentially, this means that there is the same visual theme running through each item, so they appear to be part of a managed portfolio of services—just the kind of language that your clients might want to hear. For our accountancy company everything should have a serious yet accessible feel: invoices, business cards, letterheads, and other documents should all have the same identity. As we explored earlier, choose a "family" of materials to reinforce the message.

Karim Bertrand
FCIB, AFA, MCMI

122 East Block, Sheridan Avenue, New Town, NT227
T: 0870 67651   F: 0898 78521

## FRONT BUSINESS CARD

The discreet, but friendly and professional card design now appears part of a family of products that all carry the same design message. The effect is a collective one.

## THE BROCHURE

The brochure is a difficult challenge to get right: choose too flimsy a paper and it might appear disposable or "cheap" too smart and glossy and your service might appear to be too expensive.

 **SEE ALSO: 148 for related designs**

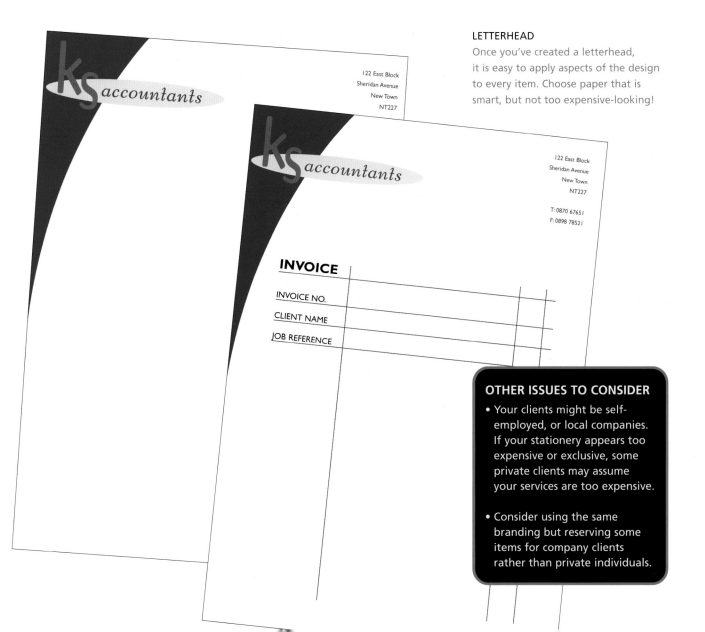

### LETTERHEAD
Once you've created a letterhead,
it is easy to apply aspects of the design
to every item. Choose paper that is
smart, but not too expensive-looking!

**OTHER ISSUES TO CONSIDER**

• Your clients might be self-
employed, or local companies.
If your stationery appears too
expensive or exclusive, some
private clients may assume
your services are too expensive.

• Consider using the same
branding but reserving some
items for company clients
rather than private individuals.

# Brand design: accountant

**Packaging all of your stationery and promotional items in a presentation folder is a strategy that might get you noticed if you plan to expand your business into a full-blown concern. The idea is to get people to keep the information.**

Presentation packs such as this give your clients a sense of seriousness about what you do. Here we have created a simple pack, which holds a letter, a brochure, and your business card. When folded, our version is slightly smaller than A5 (half-letterhead sized) to fit a standard envelope —it's important to make it easy to mail. A design strategy like this adds to the perceived value of the material, and you can use it for several years.

**FRONT COVER**
We've taken elements of the identity and created a smart and respectable-looking cover. The graphic suggests you can help navigate a world of figures.

**THE FOLDER**
The pack itself is made following a very simple template as shown opposite. The business card slots neatly into one of the folded flaps.

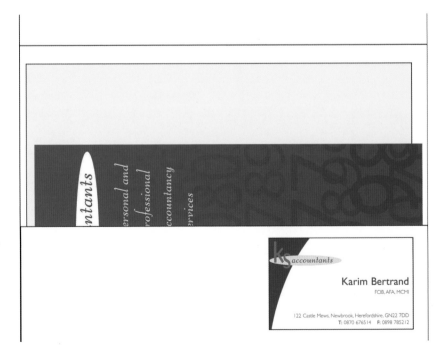

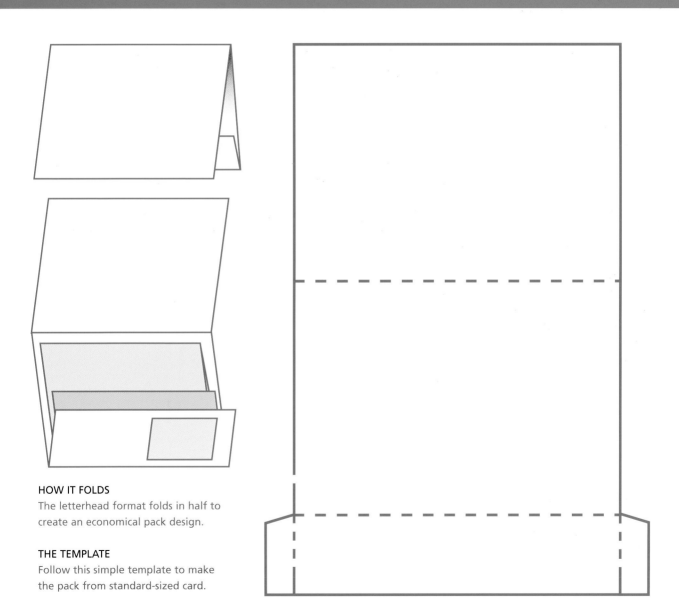

## HOW IT FOLDS
The letterhead format folds in half to create an economical pack design.

## THE TEMPLATE
Follow this simple template to make the pack from standard-sized card.

### School's Swimming Championship

**1**ST PLACE

*Event* _____

*Awarded to* _____

*Date* _____

*Sign Here*

_____

### FOOTBALL REGIONAL CHAMPIONSHIPS

_____

SIGN HERE              SIGN HERE

### ...KE'S SCHOOL SPORTS AWARD

_____

_____

**Awarded to** _____

**Date** _____

SIGN HERE              SIGN HERE

_____

# CERTIFICATES

Certificates might seem to be things that don't require much creativity or imagination. In fact, they are one of the few pieces of graphic design that a person might hang on to for a lifetime, remembering an achievement, a moment, or an important milestone in their life. So why not go to a bit of trouble to create something memorable? Events might include children's sports days, spelling competitions, tests—perhaps even reaching a certain height or age. You could even make a certificate to amuse a loved one, or cheer up someone who's having a difficult time. The few hours you spend creating a simple document may give someone special a memento to cherish for the future.

# Certificates

**Simple certificates can be easily made in any package, including your wordprocessing program. The art is in creating elements that add a splash of color, originality, and perhaps humor make them truly memorable to the recipient.**

**GET INSPIRATION**
Have a look at the traditional elements of any certificates you may have, and then make a brighter, more fun version of your own.

Look to source or create an eye-catching border. Track down a clip art source or Dingbat font for individual graphics that you can use to create the border—as we've done with the "footballs" border opposite below, which is made up of a single football icon cut and pasted into a row. The footballer graphic is another Dingbat icon, which we've "knocked back" in a pale color so it sits behind the text. The final stamp of authority makes it "official."

**DIPLOMA CERTIFICATE**
A diploma-style approach needs to look authoritative, so choose a traditional script font and think about a border.

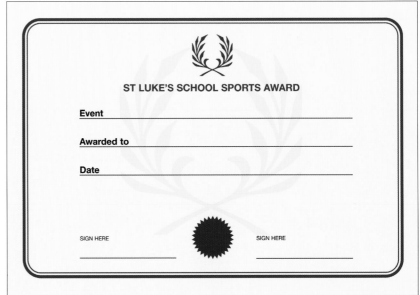

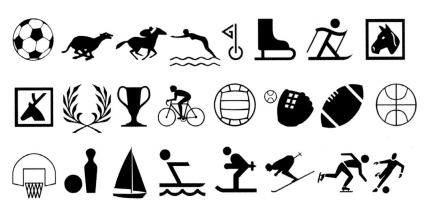

## DINGBATS AND CLIP ART

You can find graphics like this in Dingbat fonts, or in online clip art resources.

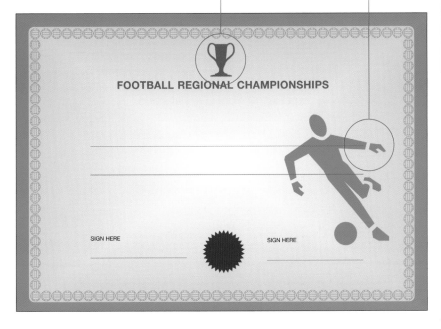

FOOTBALL REGIONAL CHAMPIONSHIPS

SIGN HERE

SIGN HERE

### OTHER ISSUES TO CONSIDER

• When you're making a certificate that you need to look prestigious (and also want to last for a number of years), then it's important to choose a good-quality paper. You might want a paper that has a parchment, marbled, or "elephant hide" texture; alternatively (or in addition), think about papers that are subtly colored with a dash of ivory or cream. All of these touches will add to the impact of the design, and make it seem much more valuable to the recipient. Perhaps get it framed.

### MAKE A STAMP

Creating a simple stamp in a drawing program (or using clip art, a dingbat, or scanning an original) helps make your certificate look authoritative.

# Certificates

**Now you've got the general idea, you can begin to explore ways of making the certificate more personal, and of producing different versions of it for different levels of achievement, runners-up, and so on...**

Have a go at creating a logo for the event. This swimmer graphic was created by using a swimmer icon from a Dingbat font, set over a solid oval shape, which you can draw using an ellipse tool in either your illustration or image-editing package. We filled the oval with color, and "reversed out" the logo in a pale tint. Again, the subtle use of a script font makes the document reflect a level of achievement.

**MAKE A LOGO**
Logos such as this can be created with little effort using clip art, Dingbat fonts, and simple shapes you can draw with the various shape tools at your disposal.

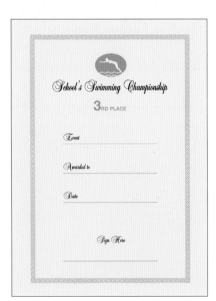

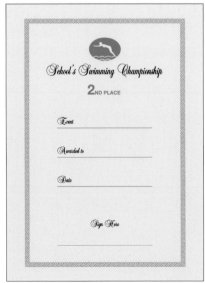

**DIFFERENT COLORS**
Create a set of certificates using a range of colors to reflect either different stages of a competition, or 1st, 2nd, and 3rd placings.

**CONSIDER PAPER OPTIONS**
If you can find the raw materials, you can match your color choices to paper options—e.g. yellow graphics with a very pale yellow (cream) paper. Remember that a pale tint of red will be pink.

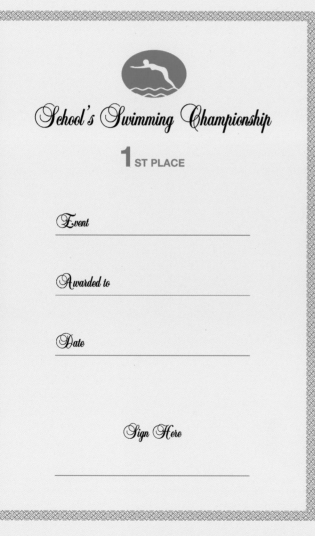

School's Swimming Championship

**1**ST PLACE

*Event*

_____

*Awarded to*

_____

*Date*

_____

*Sign Here*

_____

### FONTS

You may have one or two script-style fonts already. If not, look online. It's best to use upper and lower case for legibility.

*ABCDEFGHIJKLM*
*NOPQRSTUVWXYZ*
*abcdefghijklmnopqrstuvwxyz*
*1234567890*

TRICHPUNKT MEDIA
DESIGN AND ART DIRECTION

STRICHPUNKT
MEDIA

DESIGN AND ART DIRECTION

STRICHPUNKT
DESIGN AND ART DIREC

# MULTIMEDIA

One of the exciting things about digital technology is that we can all become home publishers, videomakers, composers, and photographers—as well as graphic designers! If you have a new computer, then you can almost certainly create your own CD, or even DVD, with some widely available tools, many of which are preinstalled with either Windows or Apple Mac systems. This is a golden opportunity to put your growing graphic design skills to good use by making professional-looking covers and labels for your work. CD label- and cover-printing software is available in many local stores, and it is usually inexpensive. You can even buy special printers that print directly onto CDs and DVDs if you want to get really ambitious.

# Multimedia

**Today you can store any type of digital information on disk, from video and still or moving graphics to presentations for your business. But it's vital to make the package look attractive or the contents might never be seen.**

This media company has produced a very simple but effective design based on a clear grid of squares in a lighter tone. Any number of squares from the grid can be removed to allow room for type, pictures, or other information—in this way the underlying structure of the design becomes a visible element of the design, which is a trend in some modern graphics. It suits this type of work.

**CD FRONT COVER**
The front cover can also be the front cover of a booklet, or a simple leaflet, which puts four sides at your disposal.

**FULL ARTWORK: FRONT AND BACK**
Create a single piece of artwork for front cover and back cover—which the viewer will see when they open the case.

**HOW IT FOLDS**
A single sheet with a centerfold is simple to produce and gives you a flexible space for creative layouts.

STRICHPUNKT MEDIA DESIGN AND ART DIRECTION

STRICHPUNKT MEDIA DESIGN AND ART DIRECTION

**STRICHPUNKT MEDIA**
DESIGN AND ART DIRECTION

### CD INLAY
This is the card that sits under the tray of "jewel cases," (the disk cases that have a transparent door and inner tray).

### OTHER ISSUES TO CONSIDER
- Although CD artwork is simple to design, it can be fiddly and time-consuming to make.

- Choose a card that is printable but easy to score, cut, and fold.

- Many CD labeling kits give you templates for covers and inlays.

- Consider designing a vinyl-style card-based slip case instead.

### THE TEMPLATE
These folds hold the inlay in place, but also form the spine that will be visible on the shelf.

### THE DISK
Many printers come with label-printing software and templates ready to use.

**STRICHPUNKT MEDIA**
DESIGN AND ART DIRECTION

# Multimedia

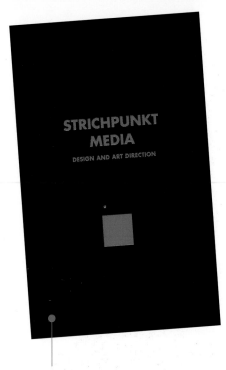

**If you're ambitious to put visual media on a DVD to send out, then you need to think of strategies to give your work the best possible visible impact. This means thinking about how DVDs are stored on the shelf.**

The differences between designing a DVD and a CD cover are twofold: first, the template for a DVD cover is less fiddly as you are dealing with a single sheet that sits in the transparent pocket of a standard DVD case. That said, DVD cases will in practice be identified by the spine as much as the front cover, so ensure it is instantly recognizable and legible—a design feature, not an afterthought.

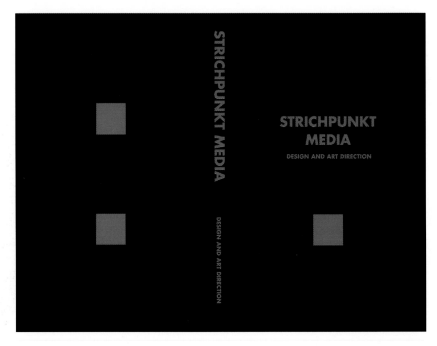

**FRONT COVER**
DVD covers are in portrait format (tall and thin) rather than square, so ensure your design concept considers both.

**FRONT AND BACK ARTWORK**
The extra height of the portrait format gives you a different shaped frame with which to work, creating new challenges to make the design relevant to the space. Note the extra colored square.

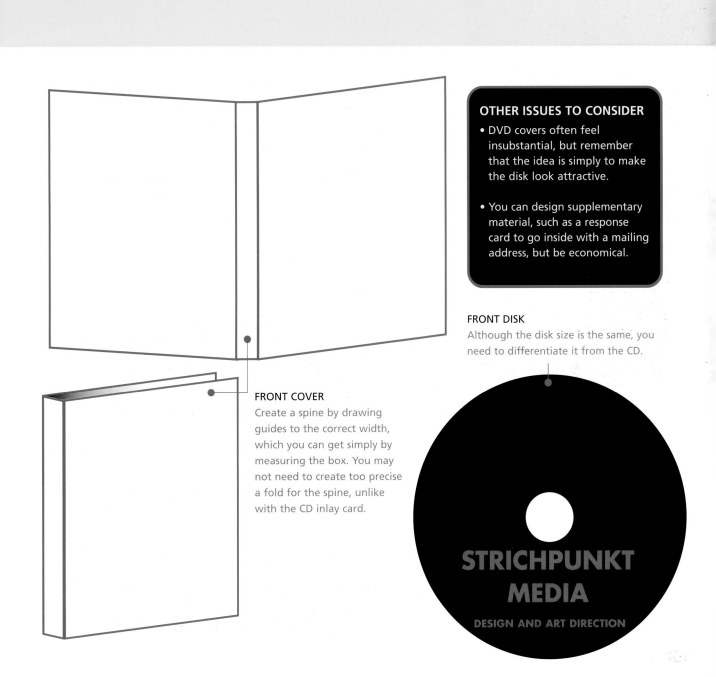

**OTHER ISSUES TO CONSIDER**

- DVD covers often feel insubstantial, but remember that the idea is simply to make the disk look attractive.

- You can design supplementary material, such as a response card to go inside with a mailing address, but be economical.

**FRONT DISK**

Although the disk size is the same, you need to differentiate it from the CD.

**FRONT COVER**

Create a spine by drawing guides to the correct width, which you can get simply by measuring the box. You may not need to create too precise a fold for the spine, unlike with the CD inlay card.

**STRICHPUNKT MEDIA**

DESIGN AND ART DIRECTION

# Multimedia: inspirations

**Packaging and label designs for DVDs don't have to be boring. Here are some examples of good typography, innovative packaging, and unusual artwork to help inspire you to think more creatively about your designs.**

**B**udget might be your only limitation, but if you're handmaking a small quantity of DVD cases for friends, or to use as examples of your work, it will cost you no extra money (and little extra time) to craft something that is a bit more innovative and inspiring than the standard DVD fare. Consider incorporating into your design how the case will open, as in the design for technology company Verso, below.

### CUSTOM-MADE CASES
A custom-made wallet with a tear-strip for a promotional DVD of Norwegian designers. Designed by Non-Format.

### DESIGN AS FORMAT
Croatian technology company Verso commissioned Likovni Studio to create this beautiful piece of packaging.

### THINK OUTSIDE THE BOX!
• DVD covers are often designed to fit in the front, transparent pocket of a standard Amaray DVD case. If this is the only option, then try to tie yours in with the label design to create a graphical theme.

• For small numbers, why not handmake a DVD slipcase in an unusual format?

FRONT COVER
"Power Manga" graphics in a Japanese style for the Cartoon Network, by design company Craftyfish.

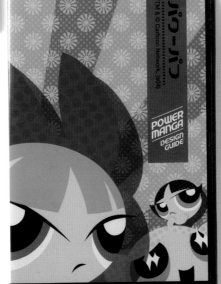

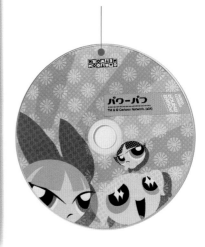

FRONT COVER
US designer and animator Barbara Rosenthal created this simple piece of design using a standard Amaray DVD case (plastic wallet with front pocket).

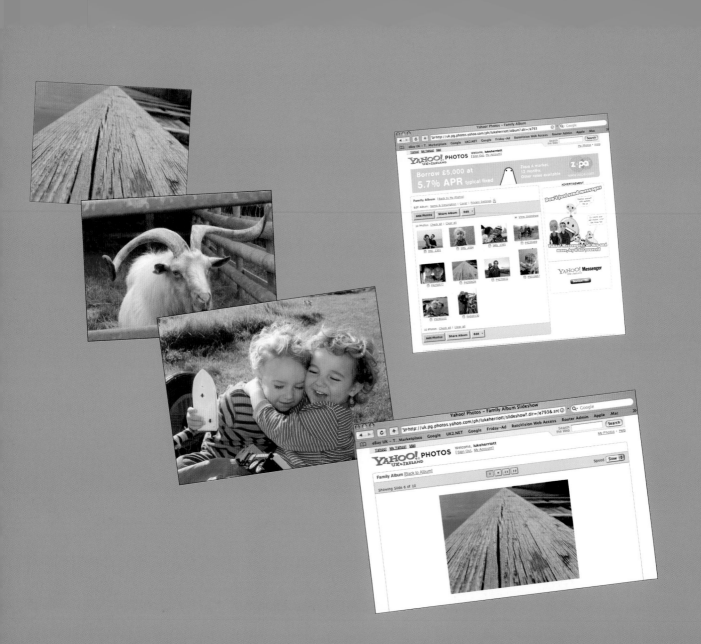

# FAMILY ALBUM

It is easy these days to create online photo albums, blogs, portfolios, and personal websites. There is a huge number of Web sites offering free services where you can upload and share your images with others. Many also offer you the ability to create postcards, greetings cards, and so on, which can be printed and mailed out to friends' addresses. These are a great way of sharing images of your life with friends and family, so why not make the best of what's available and create some truly eye-catching, colorful, and attractive-looking family albums?

# Family album

**There are numerous online resources that enable you to put together a family album of your own. The key is to personalize it and use some of your new knowledge of creating visual impact to make the most of its appeal.**

You can often create your own "look" by playing with the various color options, and formats, and adding type, and so on. Just because you are using an online service doesn't mean that you can't make the most of what's on offer to create something that is "your space" rather than merely a series of options on a global mega site.

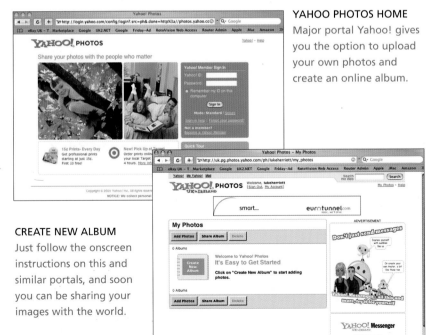

**YAHOO PHOTOS HOME**
Major portal Yahoo! gives you the option to upload your own photos and create an online album.

**CREATE NEW ALBUM**
Just follow the onscreen instructions on this and similar portals, and soon you can be sharing your images with the world.

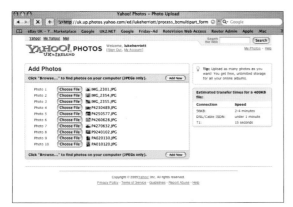

## SELECT AND UPLOAD IMAGES

Don't upload everything en masse or without going through a rigorous process of selection.

## VIEW AN IMAGE

Soon, your online album can be a resource to last a lifetime.

# Family album

**You might wonder why we should feature a "how to" section about online services. Learning the basics of putting together a simple album with readily available tools is good practice for planning your own Web site, as we'll see later.**

The trick is to be selective and rigorous in your choices. Don't upload masses of undifferentiated or similar images; instead, concentrate on telling a story and using a smaller number of pictures to lead the viewer (and reader) through the series of events. "Less is more," as they say. With online albums, it's better to tell a story with a few good images than it is to overwhelm people with hundreds.

**MY PHOTO ALBUM PHOTOS HOME**
myphotoalbum.com is another well-designed and simple site (which are often the same things) that offers a range of image-related services.

**CREATE AN ALBUM**
The onsite instructions are simple and easy to follow. Good practice for designing your own Web site.

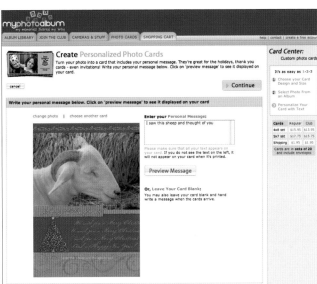

## EXTRA FEATURES

You can use the service to create a range of spin-off products and services: good for design inspiration.

### ISSUES TO CONSIDER

- Many portals offer the ability to create postcards, greetings cards and so on, which you can print and mail—or email.

- Use these sites in the way that they're intended, but also as a way of learning the ropes of what works and doesn't work online—pre-select your material; tell a story; make it easy to navigate.

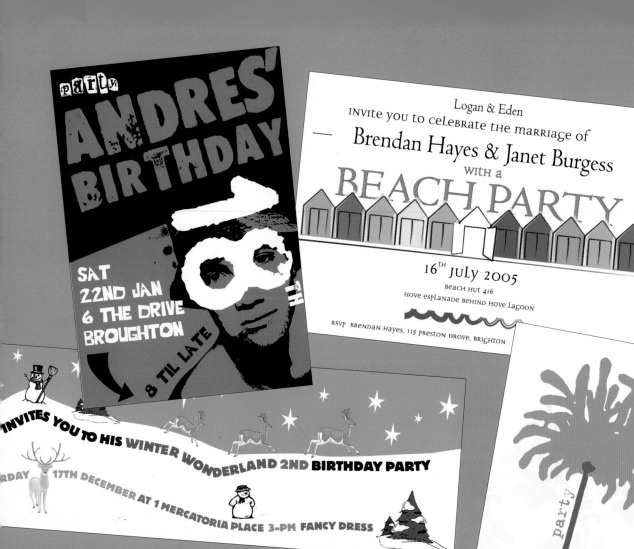

party
**ANDRES' BIRTHDAY**

18

**SAT
22ND JAN
6 THE DRIVE
BROUGHTON**

8 TIL LATE

Logan & Eden
INVITE you to celebrate the marriage of
**Brendan Hayes & Janet Burgess**
with a
**BEACH PARTY**

16ᵀᴴ JULY 2005
BEACH HUT 416
HOVE ESPLANADE BEHIND HOVE LAGOON

RSVP  BRENDAN HAYES, 115 PRESTON DROVE, BRIGHTON

INVITES YOU TO HIS WINTER WONDERLAND 2ND **BIRTHDAY PARTY**

...RDAY  17TH DECEMBER AT 1 MERCATORIA PLACE  3-PM  **FANCY DRESS**

anniversary party

# INVITATIONS

Invitations cover a whole range of events, from small dinner parties to the most extravagant celebrations, from teenage houseparties to baby's first birthday, and from informal get-togethers to lavish society weddings and religious ceremonies. For any designer, this means that the brief can be demanding and the client different every time—which is just what it's like being a professional designer! This gives you a golden—or maybe silver or diamond—opportunity to experiment and be imaginative.

# Invitations

Here are two very different designs for two very different young people's celebrations: a toddler's second birthday, and a teenager's houseparty. Both make use of simple graphic devices that are right for the subjects.

Think about your format, how it will fold, how you will print it, and innovative ways in which you can source or create graphics yourself to suit the personality. For our toddler's design we created a white landscape shape over a cyan box for the sky. For our teen we turned a portrait into an iconic, poster-style graphic.

**CLIP ART RESOURCES**
All the images are examples of "found" clip art that populate our landscape. The stars add visual magic.

**HOW IT FOLDS**
Printed edgewise on letter-sized (A4) card, this folds into an almost "widescreen" landscape shape.

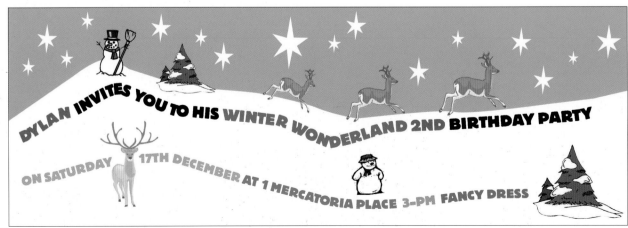

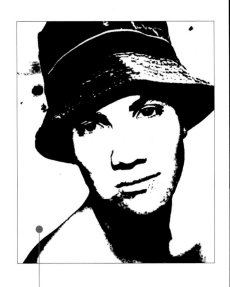

**THE IMAGE**
We turned a portrait into a graphic by first making it into a grayscale image, and then using the Posterize command.

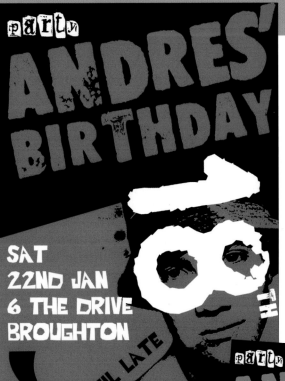

**COLOR VARIATIONS**
Increasing the contrast in such poster-style graphics lends itself to applying different colors to the strong black to create a stunning final image.

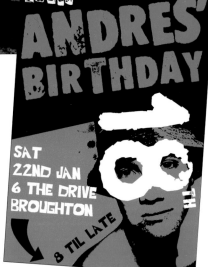

**OTHER ISSUES TO CONSIDER**

• Parents of babies and toddlers can be very competitive when it comes to wanting the best for their children, so make sure your design is as eye-catching and original as possible!

• For teen images and artwork, try to source fonts that have an edgy, club-style feel, and try exerimenting with brush textures and filters to maximize the "urban" quality. For our teen invite, we've used a stamp-style font and turned the "8" of the "18" graphic into a pair of shades.

• Try different color combinations, but watch your legibility (see right).

# Invitations

**Here's an invitation in an entirely different style—something a bit more restrained and tasteful for an anniversary. This makes use of found patterns and textures that you can scan or source and import as a background: simple and effective.**

The main image is a graphic flower. You could create such an image by scanning a real flower and then perhaps adding solid color, or using a filter to give it more of an illustrative look. We've also scanned some classic floral-motif wallpaper and run it in a pale tint as a textured background. This card will fit into a standard "business letter" envelope. Perhaps invest in some smart parchment envelopes.

**THE INVITATION**
This unusual design is entirely based on a floral theme. It would suit a textured, uncoated paper stock.

**THE TEXT**
Set it at an angle in a page-layout program, rotate it in your image editor, or set it along a path (see your manual).

**THE IMAGE**
We scanned a flower and then applied filters and brushes to get this effect. Try dried or pressed flowers and leaves.

1st anniversary party

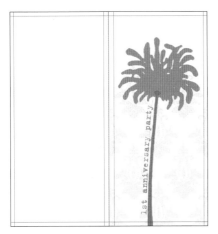

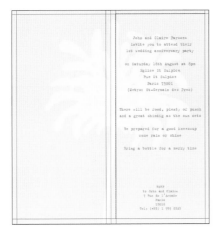

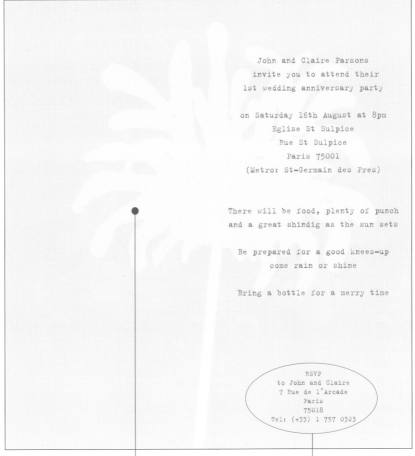

John and Claire Parsons
invite you to attend their
1st wedding anniversary party

on Saturday 16th August at 8pm
Eglise St Sulpice
Rue St Sulpice
Paris 75001
(Metro: St-Germain des Pres)

There will be food, plenty of punch
and a great shindig as the sun sets

Be prepared for a good knees-up
come rain or shine

Bring a bottle for a merry time

RSVP
to John and Claire
7 Rue de l'Arcade
Paris
75018
Tel: (+33) 1 757 0323

## INSIDE AND OUTSIDE
We used the same image across the
entire width of the inside of the card,
and a two-column grid sits on top of it.

## BACKGROUND IMAGE
Here's an example of playing around
with the "colorways" of a graphic, here
reversing it out of a pale tint.

## TEXT
The text is in the same color as the
flower on the front. Always ensure that
overlaid text is legible against an image.

# Invitations

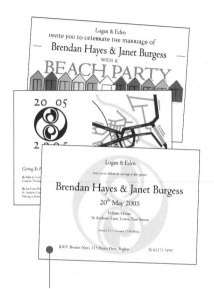

**Usually, wedding invitations need to convey a lot of information, including maps and directions, reception details, and so on. As always with graphic design, see this as a creative challenge rather than a limitation.**

This design uses three separate cards that link together to hold all of the essential information. The main card is formal, classic, and sophisticated, as most traditional wedding invitations should be. The map and directions card retains the same typography and graphic device, but simply presents the vital information. Finally, the party invitation is linked by a common typographic style, but uses bright colors and images to give it a celebratory feel and personality.

**THE INVITATION PACK**
The important thing to do when creating a range of items for the same event is to ensure that there is a continuity of design elements.

**THE INVITATION**
A serif font gives this the traditional aspect, while the graphic device is decorative, but also suggests both a ring and the union of two people at the ceremony.

Logan & Eden

*invite you to celebrate the marriage of their parents*

## Brendan Hayes & Janet Burgess

20th May 2005

Pelham House
St Andrews Lane, Lewes, East Sussex

*Arrival 11.15 Ceremony 12.00 Midday*

*RSVP Brendan Hayes, 115 Preston Drove, Brighton*      *Tel 01273 5499*

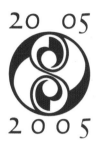

**2005** **2005**

*Getting To Pelham House*

**By Train** to Lewes Station and a 5 minute walk to Pelham House.
London: 70 minutes approx. Brighton: 10 minutes

**By Car** From Brighton take the A27 to Lewes. Proceed along the High Street.
St. Andrews Lane is the first small right turning after 'Monsoon'.
Parking is limited, more space is available at Lewes Railway station.

## THE INVITATION

The most important thing here is simple, accessible information. Perhaps download a map off the Internet and then rework it using your chosen colors.

## THE INVITATION

This is the "personal" part, the couple's personalities coming through when all the formal stuff has been dealt with.

Logan & Eden
INVITE YOU TO CELEBRATE THE MARRIAGE OF

# Brendan Hayes & Janet Burgess

WITH A

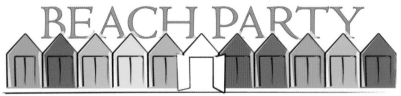

BEACH PARTY

16TH JULY 2005

BEACH HUT 416

HOVE ESPLANADE BEHIND HOVE LAGOON

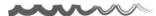

RSVP  BRENDAN HAYES, 115 PRESTON DROVE, BRIGHTON          TEL 01273 5499

### ISSUES TO CONSIDER

- There are important traditions to adhere to, but also the unique personalities of the happy couple to consider.

- An alternative strategy would be to design a formal invitation and a directions card, but then package them in a folder that is more about the couple-to-be.

HAPPY BIRTHDAY

Good Luck

Be ♥y valentine

you're a star

# GREETINGS CARDS

We all know how difficult it is to find the right greetings cards for just about any occasion. So many professionally produced cards seem to be uninspired, unoriginal, or inappropriate for friends, family, and other people we know. This is why designing and making greetings cards is such an exciting area for graphic designers, as it offers you the means to impress people with your skills by making something personal that people appreciate and which you know will be seen and enjoyed.

**SIMPLE HALF FOLD**

**One way of making your cards stand out from the crowd of unsophisticated mainstream cards is to combine an innovative choice of materials with unusual folds, cutouts, and other "physical" design features.**

Here are some useful and inspirational templates for making cards that have a bit more "presence" than the usual cards you'll probably find in your local stores. The key to remember is to choose materials that are sufficiently robust to stand up on a shelf without sagging or falling over. Think about unusual textures and paper choices if you plan to handmake your cards, bearing in mind how any printed design elements might reproduce on very porous surfaces. Consider using colored paper stocks and having no printed design at all—perhaps go for a combination of cutout, unusual format, and attractive materials.

**PART FOLD**

**THIRD FOLD**

**CONCERTINA FOLD**

**FORMATS AND FOLDS**
Think about the size you want your card to be. This is often determined by envelope sizes. However, by thinking about different ways of folding your card, it is possible to come up with something a bit more original and inspired.

## CUTOUTS

Try some simple cutouts. This is an effective way of creating a more exciting card. The cutout can reveal a different image behind it, or perhaps a metallic paper through the window.

# 11 Greetings cards

There are plenty of occasions when an understated card design that's simply about texture, materials, and cutouts simply isn't right. Here are five alternative inspirational strategies for making eye-catching and original greetings.

Other strategies include sourcing (and perhaps shooting) an original image that says something about the personality of the recipient; combining graphic elements, message, and type style for greetings that have a personal touch; combining windows and cutouts with images and messages; making a virtue of primitive or hand-drawn graphics by scanning them or editing them in-software; and creating reuseable designs that might be a brand extension for your home business. Here are examples of all five approaches.

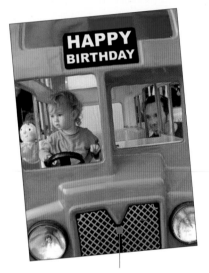

**MANIPULATE A PHOTO**
Source a colorful, fun photo for an excellent card design. Try adding your own type and images in a collage style.

**BE CREATIVE WITH TYPE**
This heart shape has been neatly incorporated into the type and looks clean and sophisticated.

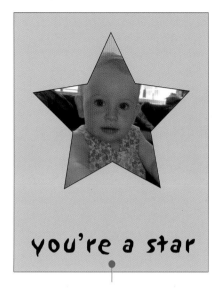

**A SIMPLE CUT OUT**
This simple star shape reveals the image inside. Combine it with a hand-scripted font style for a "naive" design.

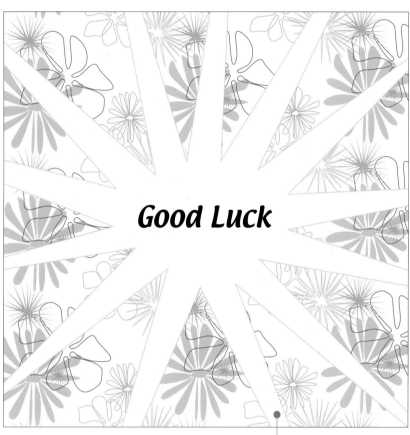

*Good Luck*

**GRAPHIC TECHNIQUES**
We've drawn a heart in a drawing package and applied a filter to give it a "scribbled" look. Hand-drawing is fine.

**CREATING PATTERNS**
Our florist pattern has been developed to make this card—a potential spin-off product with a range of messages?

# MERCATORIA AREA RESIDENTS' GROUP

## NEWSLETTER

Issue 01 December 2004

### Welcome to the first Mercatoria Area Residents' Group Newsletter.

MARG was formed earlier this year by a group of residents concerned about the proposal to partly demolish and redevelop St Leonards Mosque in Mercatoria. The site comprises one of the last few remaining National School buildings, in this case designed by Decimus Burton in 1847.

In June of last year, Hastings Borough Council Planning Board ignored the advice of their own Conservation Officer, English Heritage and the carefully argued pleas of local residents and granted outline planning permission to this ill-advised scheme. The scandalously inept drawings formed the basis of the new 'detailed' plans submitted recently for approval by the Planning Department.

Thanks to a barrage of letters from local residents, these totally inadequate plans have been returned to the architects acting on behalf of the Mosque Association. We are now awaiting a revised set of plans to be put forward to the Planning Department, which in turn will be made available for public comment.

It has to be stressed that the Council has granted outline planning permission and although the latest set of drawings has been sent back, the redevelopment has not been stopped. The Mosque Association has five years in which to commence building work from the date of outline planning permission, which is June 2003. However, as far as MARG is concerned, this is far from a lost cause.

Getting permission to demolish a substantial part of an historic building in a Conservation Area is not a

straightforward matter and there is a long way to go before we reach the stage where we accept redevelopment is inevitable.

**It must be said loud and clear**

St Leonards on Sea Church School, Mercatoria, now St Leonards Mosque.

---

## Tide guide

02 June 2006

MUSIC
COMEDY
ART
DESIGN
POETRY
THEATRE
LITERATURE
NEWS
AND MORE

### THE ONLY WORTHWHILE GUIDE TO WHAT'S HAPPENING ON THE SOUTH COAST

**EDITOR**

A survey conducted...
Ann is one of an ever-gr...
tired of being kept on hold. A third of those differ...
up within three minutes. Even so, we spend an average o...
waiting for service on our phones.

Meanwhile, a poll by website 'Greensleeves.co.uk' found the top three most annoying hold tunes to be 'Greensleeves', 'Nessun Dorma' and 'Simply The Best' by Tina Turner.

This is bad news for customers, but worse for the companies responsible. Like Ann, many people are prepared to vote with their feet. 50% of consumers claim to have given up waiting on the phone to a retailer and to have permanently avoided the brand and organisation afterwards. So why do companies use these systems in the first place? Cost seems to be one factor – it's far cheaper to have a computer deal with calls than it is to employ extra telephone operators.

partydyards at Hastings DANCE LIVE FESTIVAL this summer

---

## music

### Supergrass/ Bonny Conn/ The Yeah Yeah Yeahs at The Festival Hall

by Chris Broughton

At first glance, the bill of this penultimate Meltdown show seems to back up the charges of conservation levelled at the host. I mean – Supergrass, come on. Surely they became passe the moment the ill-advised Britpop 'phenomenon' disappeared up it's own flag-waving fundament. And yet tonight the increasingly less hairy Oxford pop-rockers demonstrate that solid songcraft in a classic three-piece format needn't mean The Stereophonics, especially when combined with the ebullient joie de vivre they always seem to personify. New songs like 'Grace' and 90-second shunting session

> "Surely they became passe the moment the ill-advised Britpop 'phenomenon' disappeared up it's own flag-waving fundament"

'Never Done Nothing Like That before' still have enough hooks to reel you in on first hearing, and an explosive encore sees the band teasing out the staccato opening of 'Lenny' for maximum impact and demolishing 'Caught By The Fuzz' as though they really were still 'Only 15'. As the drum-kit crashes off it's riser and the boys sharply exit stage left, we're left to reflect that when it comes, there will be a mighty 'Greatest Hits' album. And they resist calls to return and do 'Alright', thank God.

Meanwhile, Bobby Conn fails to project his psychotic glam-metal cabaret in the biggest venue he's ever played in London. His band strikes all the right hard rock poses, and fiddle player Monica Boubou is Yehudi Menuhin reborn as a French goth, but the diminutive frontman is just too...well, small to make his usual impact. And believe me, up close he's more frightening than your childhood nightmares.

002/003

Music
Comedy
art
Design
poetry
theatre
literature
News
Listings

---

W.A.Plumridge

There's loads of great stuff happening all the time

There's loads of great stuff happening all the time

There's loads of great stuff happening all the time

There's loads of great stuff happening all the time

There's loads of great stuff happening all the time

There's loads of great stuff happening all the time

# NEWSLETTERS AND MAGAZINES

One of the biggest but most rewarding challenges that a graphic designer faces is creating a newsletter or magazine. The design has to anticipate every possible way in which a page might be laid out, and also create a range of different design elements and sustain them not only over one issue of the publication, but perhaps dozens of issues in the future. Books aside, magazines and newsletters are the ultimate example of a working design that incorporates text and images creatively, and which people are likely to spend more than a few seconds reading and exploring. In many cases, a magazine designer will only be involved in the first couple of issues, and will thereafter have to hand the design over to someone else to manage...

# Newsletters and magazines

**Any newsletter or magazine design needs to create a presence, a character, and a sense of continuity—from issue one. This is a design that will be adapted for the needs of each issue, and yet appear to have the same basic design.**

## CREATING A NEWSLETTER

The "masthead" is the name of the publication on the front cover. If the newsletter is folded into three horizontally, the masthead, being in the top third, will become a front page.

All magazines and newsletters need a strong "masthead": this is the main title of the publication, which like a flag or banner, announces the publication's name to its readership. Before designing it and the rest of your publication, think about who the readership is: what type of person will read it, and why? Designing issue one means considering how future issues will look. You're designing a scheme that will be reused—with the flexibility to have variety from issue to issue.

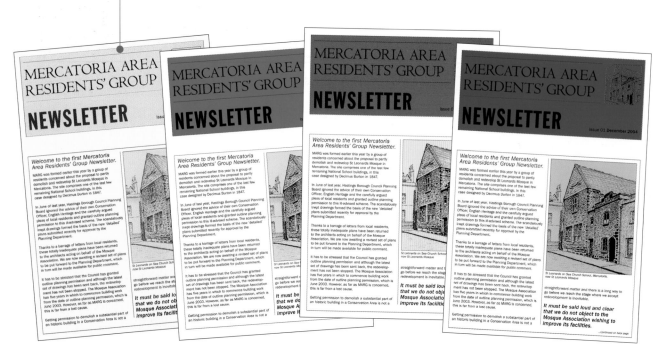

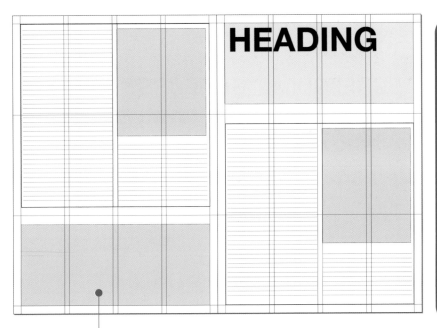

# HEADING

### A WORKABLE GRID

Setting up a solid grid and structure from issue one means that producing future issues will be easy. This design has a four-column grid. There is plenty of scope for flexibility, with the ability for either text or images to run across one, two, three, or four columns. This gives your design a solidity from issue to issue, but also the potential to have great variety and to make the best visual use of your material.

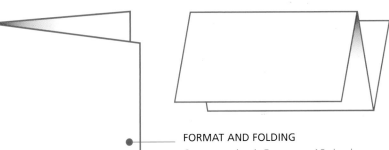

### FORMAT AND FOLDING

Our magazine is European A3-sized folded in half to make an A4 publication. This can then be folded again into three for sending out in a standard business letter envelope if need be.

# Newsletters and magazines

## THE FONTS

All fonts are clear and legible. The heading font is a serif face and looks classic. The "body copy" (main text) is a sans serif that is available in a number of weights (character thicknesses, such as bold), which gives plenty of options for headlines, captions, and so on.

ABCDEFGHILKLMNOPQRSTUVWXYZ
1234567890

ABCDEFGHILKLMNOPQRSTUVWXYZ
abcdefghilklmnopqrstuvwxyz
1234567890

## THE LAYOUT

One issue to bear in mind when evolving your newsletter or magazine design, is that people might want to advertise in it—perhaps generating income for you. Ensure that you incorporate a standard advert size and format into your design.

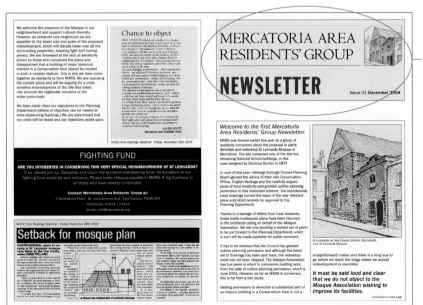

## THE MASTHEAD

This conservation group wanted a logo. We've cropped an image of a building and made it part of the masthead.

## THE LOGO

Logos on magazines and newsletters can be something factual, to help reinforce a message, or be more about a personality or set of values. Both kinds say what the magazine stands for to your readers.

If you are going to be running news stories on your front page, or elsewhere, you need to think about optional front page templates. Should your headline be on one line (single deck) or two (two deck)?

## FUTURE ISSUES

Future issues might be differentiated by different colors, perhaps, or by a different seasonal theme.

## PAPER STOCK

Consider the option of printing in black only to keep down printing costs, but using a colored paper stock for impact.

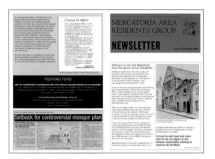

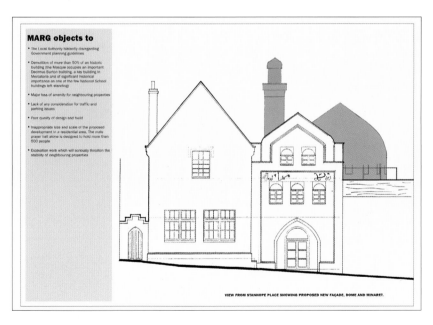

## PAGES 2 AND 3

Obviously your front page isn't the only element. It might grab the attention, but people may spend the most time reading your main news spread. Here, our grid allows us to use a large picture, which will grab the reader's attention.

## OTHER ISSUES TO CONSIDER

• Use no more than two fonts, unless you are creating some additional graphic elements. Differentiate headlines, captions, subheadings, and so on, with diffferent "weights" of type.

• Explore different type combinations, such as sans serif headlines with serif main text (body copy). Find out which combinations appeal to you.

**Formats are very important in magazine and newsletter design, as form should be a good indication of function. This event listings magazine is A5-sized, as it's designed to be picked up in cafes and bars and put in a bag or pocket.**

A good lesson to learn is that small format shouldn't mean small thinking, or that every element of your design needs to be scaled down. In fact, small formats are an excellent way of experimenting with bold design and comparatively large graphic elements. These can have a strong visual impact within the smaller frame, but without being overwhelming and appearing to "shout." Think about how little text you can have on the front cover while still being useful and informative.

### "FULL BLEED" IMAGE USE
So-called full-bleed images are images that go right to the very edges of a page. They have great visual impact and could be used to showcase local work.

### CHOOSING A FONT
Listings magazines need to make a mass of detailed information look accessible and clear, so choose your font carefully.

### DESIGNING THE MASTHEAD
One way of creating a stunning, modern design is to combine a small format, with large graphic elements, such as full-bleed images (see caption, far left) and a big, bold masthead design. This looks good, but also serves the practical function of making a small item look as eye-catching and attractive as possible from afar.

### KERNING THE TEXT
As we explored in the introduction to this book, the gaps between individual characters can be unattractive when using type at large sizes, so it may be necessary to experiment with kerning the text to reduce some of the gaps.

**ABCDEFGHIJKLMNOPQRSTUVWXYZ**
**abcdefghijklmnopqrstuvwxyz**

**1234567890**

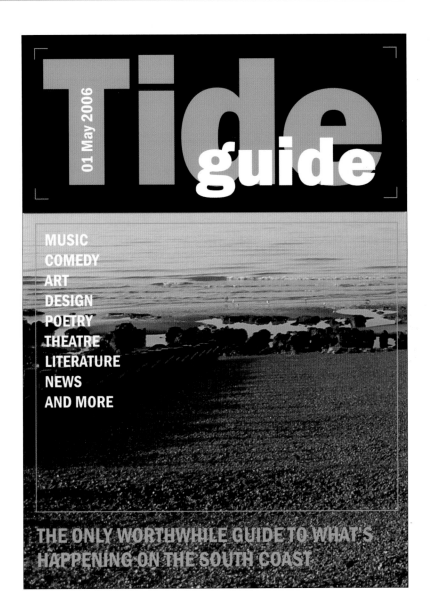

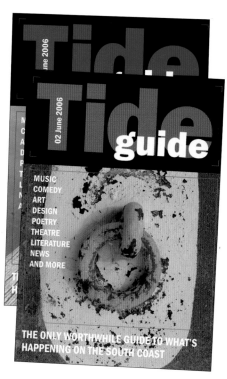

### THINK ABOUT COLOR
You can minimize printing costs by printing in just one or two colors, perhaps changing the masthead color for each issue. Make a virtue of showcasing black and white images.

### HOW WILL THE COVER CHANGE?
Full-bleed images make it easy, from a design point of view, to change the cover each week or month.

**How do you make a mass of detailed information look visually appealing, accessible, easy to navigate, and legible? Establish clear hierarchies of information, use no more than two fonts (with different weights to differentiate headings, and so on), and break up the text with careful use of color, which makes a "wall" of words look more inviting.**

Remember: most people will scan through pages quickly to find the information they need. Another design trick is to create a different grid for each different type of information—in this case, the listings (the majority of the magazine), and the feature pages. This breaks up the publication and creates variety and a "change of pace." Look through most magazines and you'll find this is a common solution.

IMAGES TO USE
With this kind of publication you need images that communicate quickly and effectively and link with the text.

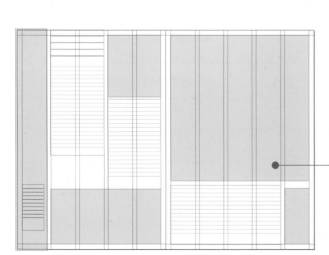

THE GRID
We've created two grids: five columns for the feature article pages and four columns with wide margins for the listings. Note the flexibility of the five-column grid (see opposite, top left.) In both grids, one column forms the black stripe.

## Supergrass/ Bonny Conn/ The Yeah Yeah Yeahs at The Festival Hall

by Chris Broughton

At first glance, the bill of this penultimate Meltdown show seems to back up the charges of conservatism levelled at the host. I mean – Supergrass, come on. Surely they became passe the moment the ill-advised Britpop 'phenomenon' disappeared up it's own flag-waving fundament. And yet tonight the increasingly less hairy Oxford pop-rockers demonstrate that solid songcraft in a classic three-piece format needn't mean The Stereophonics, especially when combined with the ebullient joie de vivre they always seem to personify. New songs like 'Grace' and 90-second shouting session

*"Surely they became passe the moment the ill-advised Britpop 'phenomenon' disappeared up it's own flag-waving fundament"*

'Never Done Nothing Like That before' still have enough hooks to reel you in on first hearing, and an explosive encore sees the band teasing out the staccato opening of 'Lenny' for maximum impact and demolishing 'Caught By The Fuzz' as though they really were still "Only 15". As the drum-kit crashes off it's riser and the boys sharply exit stage left, we're left to reflect that when it comes, theirs will be a mighty 'Greatest Hits' album. And they resist calls to return and do 'Alright', thank God.

Meanwhile, Bobby Conn fails to project his psychotic glam-metal cabaret in the biggest venue he's ever played in London. His band strikes all the right hard rock poses, and fiddle player Monica Boubou is Yehudi Menuhin reborn as a French goth, but the diminutive frontman is just too...well, small to make his usual impact. And believe me, up close he's more frightening than your childhood nightmares.

## SINK OR SWIM
### What gets your blood pressure soaring?

It makes me so mad when I phone a company and am answered by a machine. Normally I am asked to hold for an operator, and have to listen to nondescript music and the message. 'Thank you for holding. Your call is important to us so please do not hang up. As far as I'm concerned my call is not important if a company is prepared to allow me to 'hold on'. Now I refuse to deal with any company that cannot guarantee me a little personal service and a direct dial line to a real live person!

*Ann Harper – Hastings*

**EDITOR** A survey conducted last year by Cable and Wireless show Ann is one of an ever-growing number of customers who are tired of being kept on hold. A third of those interviewed said they'd hang up within three minutes. Even so, we spend an average of 45 hours a year waiting for service on our phones.

Meanwhile, a poll by website Stressbusting.co.uk found the top three most annoying hold music hits to be Greensleeves', 'Nessun Dorma' and 'Simply The Best' by Tina Turner.

This is bad news for customers, but worse for the companies responsible. Like Ann, many people are prepared to vote with their feet, 50% of consumers claim to have given up waiting on the phone to a retailer and to have permanently avoided the brand and organisation afterwards. So why do companies use these systems in the first place? Cost seems to be one factor – it's cheaper to have a computer deal with calls than it is to employ extra telephone operators.

participants at Hastings's DANCE LIVE FESTIVAL this summer

**COASTAL CURRENTS**

Theres loads of graf stuff happening all the time

Theres loads of graf stuff happening all the time

Theres loads of graf stuff happening all the time

Theres loads of graf stuff happening all the time

Theres loads of graf stuff happening all the time

Theres loads of graf stuff happening all the time

## COLOR

The two-color design is inexpensive to print. The idea is that future editions will use different colors. All images are converted to black and white and then made into "duotones" in Photoshop.

## THE LAYOUTS

The more columns you have, the more flexible you can be with the design. For magazines, the content is often very varied so flexibility is important. The wide outer column of this design allows for clear headings and a strong navigation system.

---

**MONDAY 12TH**

**THE HEADCOATS**
**The Kings Head, Brighton**
At first glance, the bill of this penultimate Meltdown show seems to back up the charges of conservatism.

**CUTTLEFISH**
**St Mary's, Hastings**
At first glance, the bill of this penultimate Meltdown show seems to back up the charges of conservatism.

**KINKY GOATS**
**The Dome, Brighton**
At first glance, the bill of this penultimate Meltdown show seems to back up the charges of conservatism.

**FOURS MORE/HELL FIRE**
**The Event, Eastbourne**
At first glance, the bill of this penultimate Meltdown show seems to back up the charges of conservatism.

**TUESDAY 13TH**

**THE HEADCOATS**
**The Kings Head, Brighton**
At first glance, the bill of this penultimate Meltdown show seems to back up the charges of conservatism.

**CUTTLEFISH**
**St Mary's, Hastings**
At first glance, the bill of this penultimate Meltdown show seems to back up the charges of conservatism.

**KINKY GOATS**
**The Dome, Brighton**
At first glance, the bill of this penultimate Meltdown show seems to back up the charges of conservatism.

**FOURS MORE/HELL FIRE**
**The Event, Eastbourne**
At first glance, the bill of

**MONDAY 12TH**

**THE HEADCOATS**
**The Kings Head, Brighton**
At first glance, the bill of this penultimate Meltdown show seems to back up the charges of conservatism.

**CUTTLEFISH**
**St Mary's, Hastings**
At first glance, the bill of this penultimate Meltdown show seems to back up the charges of conservatism.

**KINKY GOATS**
**The Dome, Brighton**
At first glance, the bill of this penultimate Meltdown show seems to back up the charges of conservatism.

**WEDNESDAY 14TH**

**THE HEADCOATS**
**The Kings Head, Brighton**
At first glance, the bill of this penultimate Meltdown show seems to back up the charges of conservatism.

**FRIDAY 16TH**

**THE HEADCOATS**
**The Kings Head, Brighton**
At first glance, the bill of this penultimate Meltdown show seems to back up the charges of conservatism.

**CUTTLEFISH**
**St Mary's, Hastings**
At first glance, the bill of this penultimate Meltdown show seems to back up the charges of conservatism.

**KINKY GOATS**
**The Dome, Brighton**
At first glance, the bill of this penultimate Meltdown show seems to back up the charges of conservatism.

**FOURS MORE/HELL FIRE**
**The Event, Eastbourne**
At first glance, the bill of this penultimate Meltdown show seems to back up the charges of conservatism.

**THURSDAY 15TH**

**THE HEADCOATS**
**The Kings Head, Brighton**

**SATURDAY 17TH**

**THE HEADCOATS**
**The Kings Head, Brighton**
At first glance, the bill of this penultimate Meltdown show seems to back up the charges of conservatism.

**CUTTLEFISH**
**St Mary's, Hastings**
At first glance, the bill of this penultimate Meltdown show seems to back up the charges of conservatism.

**KINKY GOATS**
**The Dome, Brighton**
At first glance, the bill of this penultimate Meltdown show seems to back up the charges of conservatism.

**FOURS MORE/HELL FIRE**
**The Event, Eastbourne**
At first glance, the bill of this penultimate Meltdown show seems to back up the charges of conservatism.

**SUNDAY 18TH**

**THE HEADCOATS**
**The Kings Head, Brighton**
At first glance, the bill of this penultimate Meltdown show seems to back up the charges of conservatism.

**CUTTLEFISH**
**St Mary's, Hastings**
At first glance, the bill of this penultimate Meltdown show seems to back up the charges of conservatism.

**KINKY GOATS**
**The Dome, Brighton**
At first glance, the bill of this penultimate Meltdown show seems to back up the charges of conservatism.

**FOURS MORE/HELL FIRE**
**The Event, Eastbourne**
At first glance, the bill of this penultimate Meltdown

show seems to back up the charges of conservatism.

**MONDAY 19TH**

**THE HEADCOATS**
**The Kings Head, Brighton**
At first glance, the bill of this penultimate Meltdown show seems to back up the charges of conservatism.

**CUTTLEFISH**
**St Mary's, Hastings**
At first glance, the bill of this penultimate Meltdown show seems to back up the charges of conservatism.

**KINKY GOATS**
**The Dome, Brighton**
At first glance, the bill of this penultimate Meltdown show seems to back up the charges of conservatism.

**FOURS MORE/HELL FIRE**
**The Event, Eastbourne**
At first glance, the bill of this penultimate Meltdown show seems to back up the charges of conservatism.

**TUESDAY 20TH**

**THE HEADCOATS**
**The Kings Head, Brighton**
At first glance, the bill of this penultimate Meltdown show seems to back up the charges of conservatism.

**CUTTLEFISH**
**St Mary's, Hastings**
At first glance, the bill of this penultimate Meltdown show seems to back up the charges of conservatism.

**KINKY GOATS**
**The Dome, Brighton**
At first glance, the bill of this penultimate Meltdown show seems to back up the charges of conservatism.

**WEDNESDAY 21ST**

**THE HEADCOATS**
**The Kings Head, Brighton**
At first glance, the bill of this penultimate Meltdown show seems to back up the charges of conservatism.

**CUTTLEFISH**
**St Mary's, Hastings**
At first glance, the bill of this penultimate Meltdown show seems to back up the charges of conservatism.

**KINKY GOATS**
**The Dome, Brighton**
At first glance, the bill of this penultimate Meltdown show seems to back up the charges of conservatism.

**FOURS MORE/HELL FIRE**
**The Event, Eastbourne**
At first glance, the bill of this penultimate Meltdown show seems to back up the charges of conservatism.

**THURSDAY 22ND**

**THE HEADCOATS**
**The Kings Head, Brighton**
At first glance, the bill of this penultimate Meltdown show seems to back up the charges of conservatism.

**CUTTLEFISH**
**St Mary's, Hastings**
At first glance, the bill of this penultimate Meltdown show seems to back up the charges of conservatism.

**KINKY GOATS**
**The Dome, Brighton**
At first glance, the bill of

**FOURS MORE/HELL FIRE**
**The Event, Eastbourne**
At first glance, the bill of this penultimate Meltdown show seems to back up the charges of conservatism.

**COMING SOON**

Theres loads of graf stuff happening all the time

Theres loads of graf stuff happening all the time

Theres loads of graf stuff happening all the time

Theres loads of graf stuff happening all the time

Theres loads of graf stuff happening all the time

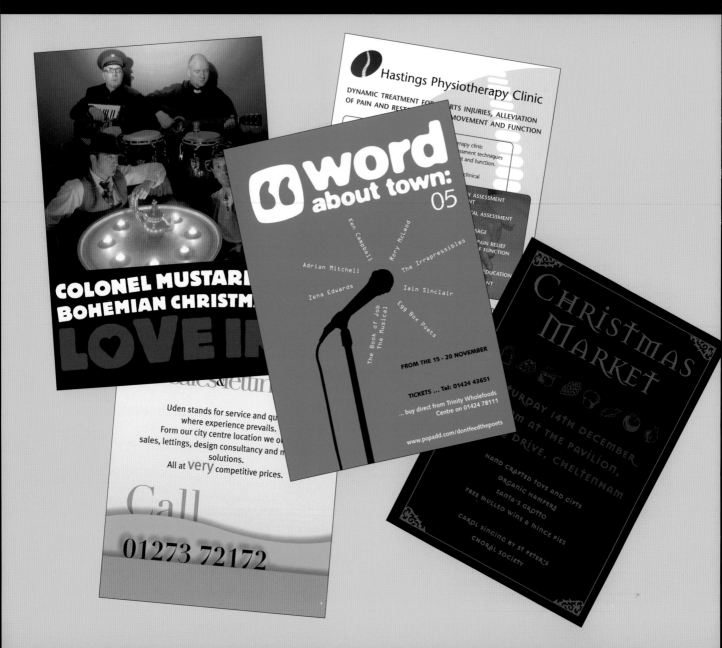

# FLYERS

Other than packaging, flyers are perhaps the ultimate in "disposable" design—designs that are seen, that communicate a message, and are then thrown away. However, unlike packaging design, a flyer may not have to develop an ongoing relationship with the viewer as the event they advertise may only happen once. Even so, flyers serve an important function: the design and message of the flyer may be the only information someone has about an event, and so it may be the sole means of deciding whether or not to go. That means that it has to get the right message to the right audience—and fast!

# Flyers: local business

**Flyers are perhaps the most "disposable" form of graphic design. The idea is to communicate a simple message to the biggest possible audience as quickly as possible, in the hope that a percentage of people will follow up the information.**

With flyers, therefore, the key is balancing the need to create instant impact and quick communication with something that will be inexpensive to produce en masse. You should also consider how much money is at stake if you don't find an audience. Is it worth a major financial outlay if the maximum return will be modest? Think about colors, materials, and printing costs.

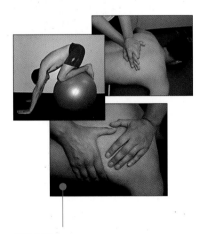

**IMAGES**
Look at the way these photos have been cropped and used to make this flyer more visually interesting.

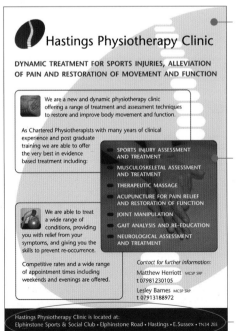

**GRAPHIC SHAPES**
The logo is used big and "knocked back" as a tint in the background. It is a simple way to give the flyer a more dynamic look.

**BACKGROUND IMAGES**
These have been converted to black and white and then tinted to give a subtle background color.

**ADDRESS**
The address details are clear and easy to read in this colored bar.

## uden
sales . lettings . management

### sales & lettings

Uden stands for service and quality
where experience prevails.
Form our city centre location we offer
sales, lettings, design consultancy and mortgage
solutions.
All at very competitive prices.

Call

## 01273 72172

## uden
sales . lettings . management

For a friendly and professional service
at the heart of the City

ELECTRIC
PALACE
Cinema

info@electricpalacecinema.com

### THE PROPERTY AGENT
The color is taken from the logo, maintaining the "corporate identity." Simple shapes have been used to suggest hills. which in this case represent the location of the office. The designer has played with type sizes and shadows to create a sense of depth, making a potentially uninspiring flyer into something much more appealing. If you have no images to play with, think about creating your own graphic shapes and backgrounds to achieve a similar effect.

### THE CINEMA
This flyer for an independent cinema simply uses a strong, atmospheric image with the cinema's logo laid over the top. The address and Web site is then placed in a clear sans serif font at the bottom left. Simple, but stylish and effective!

# Flyers: simple and festive

**Some events come but once a year. Flyers for these occasions need to be simple, direct, and effective—but also enter into the spirit of the time. As ever, there are countless interpretations you can use as a designer.**

Flyer number one is modern and contemporary, with a touch of childlike charm. A new touch is the use of a graduated tint, or gradient, behind the bauble graphics. This is where a color is faded out to create an effect similar to light falling on it. Flyer two has a more old-fashioned, traditional approach.

**THEME**
Create a simple graphic that suggests Christmas—for example, these baubles.

**GRADIENTS**
Experiment with using gradients to give the flyer a more three-dimensional feel, as in the background here.

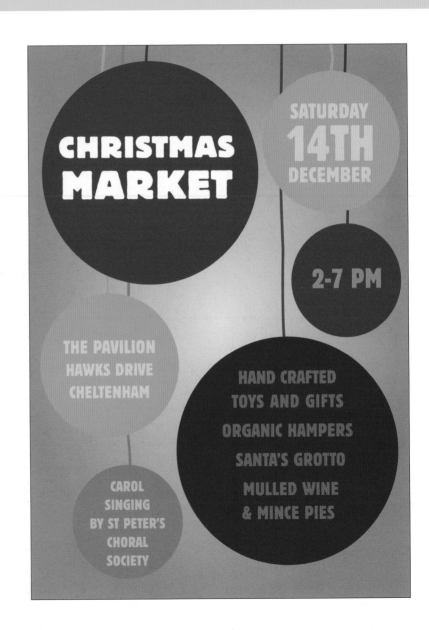

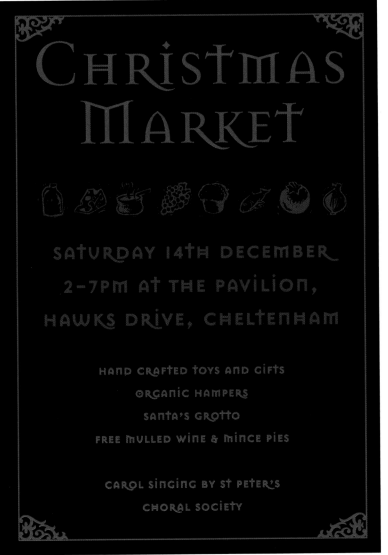

**CHRISTMAS MARKET**

**SATURDAY 14TH DECEMBER**

**2–7PM AT THE PAVILION,**

**HAWKS DRIVE, CHELTENHAM**

HAND CRAFTED TOYS AND GIFTS

ORGANIC HAMPERS

SANTA'S GROTTO

FREE MULLED WINE & MINCE PIES

CAROL SINGING BY ST PETER'S

CHORAL SOCIETY

## OPTION TWO

This is a more traditional approach to the same information. A classic Christmas-style font has been used with festive colors.

## BORDERS AND FRAMES

A simple border gives it a decorative feel. Something like this can be easily created in most packages where there are standard templates. This one was made by creating a simple keyline box in red and then adding in decorative corner pieces from a Dingbat font.

## IMAGES

The images of food on this flyer are again from a font. Alternatively you could scan or draw your own images.

# Flyers: local acts

**Local events flyers serve the same purpose as any other, but also have a role to play in developing and maintaining an audience and keeping the personality of the performers in the public eye if they do not have access to the wider media.**

How you design flyers for local performers will have a vital role in their success on the local scene. Flyers may be the only promotional item that the general public gets to see, and so the design will be all they have to go on to tell them about the style and content of the show. Don't let down a serious performer with a jokey design, or make a fun act seem po-faced or too serious. These flyers have a greater impact than most.

## ABCDEFGHIJKLMN OPQRSTUVWXYZ 1234567890

**THE FONT**
A bold, "retro" font gives the flyer a psychedelic 1960s look.

**ADD SOMETHING EXTRA...**
Tweaking the font sometimes helps give your work a new identity. We've made the center of the "o" into a heart.

**MAIN IMAGE**
The main part of the front of this flyer is a photo of the band. Red and black has been used for the type to tie it in with the image.

**IMAGE EDITING**
Look at the way these photos have been cropped and used to make this flyer more arresting.

## MAIN IMAGE

The image is placed centrally, allowing the type to fit around it.

## TYPE STYLING

The type has been placed on curved lines to create a more hand-drawn feel. Point sizes and line lengths vary. This helps create that 1960s hand-drawn poster feel. It also means the text can fit around the image.

## COLOR

The type color is restricted to black and red making it clear and bold.

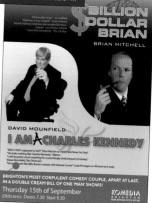

## CUT OUT THE IMAGE

Use an image-editing package to remove the background from the image.

## OTHER FLYERS

Above are some other ideas for local events designs.

# Flyers: local events

**SIMPLE AND EFFECTIVE LOGO**
This club night is for the spoken word. We've created a logo that looks friendly, encourages participation—and tells people something about the night.

**Another common type of "community" flyer is one that promotes a regular event, club, or social night. Such designs have a different purpose again: to create continuity and familiarity, as well as promote each individual event.**

This local entertainment night has a range of simple designs, branded together by its strong logo—this creates continuity. The flyers are A5 and printed in black on colored paper. This is both inexpensive and easy to do. Each night or calendar month could be differentiated by the paper color. Cost is a major factor.

**IMAGES TO USE**
Each flyer is clearly branded with the name of the event, while individual nights use different colors so that people know straight away that they are not seeing the same flyer as the previous week. This frees you up as a designer to feature some of the people involved with the event each time. Running images in black ink against a color background is a very effective poster-style design device, so ensure that your images reproduce well. Such a design could be photocopied.

**"word** 
**about town:** 
**05**

Ken Campbell

Rory McLeod

Adrian Mitchell

The Irrepressibles

Zena Edwards

Iain Sinclair

The Book of Job
The Musical

Egg Box Poets

**FROM THE 15 - 20 NOVEMBER**

**TICKETS ... Tel: 01424 43651**

... buy direct from Trinity Wholefoods
Centre on 01424 78111

www.popadd.com/dontfeedthepoets

## MAIN ISSUES TO CONSIDER

- Create designs that have an instant impact and tell people very quickly what the event is all about—both literally, and in terms of mood and audience.

- Consider whether your flyers need to be in full color and printed, or perhaps photocopied in black on colored paper.

- If your event is going to be a sophisticated one, and a money-maker, then your design needs to suggest something classy and an event worth paying for.

- Other community events don't need to go the high-cost route.

### IMAGES TO USE
This is more of an "establishing" design that could be pinned in local venues to advertize the whole concept of the night, rather than each individual event.

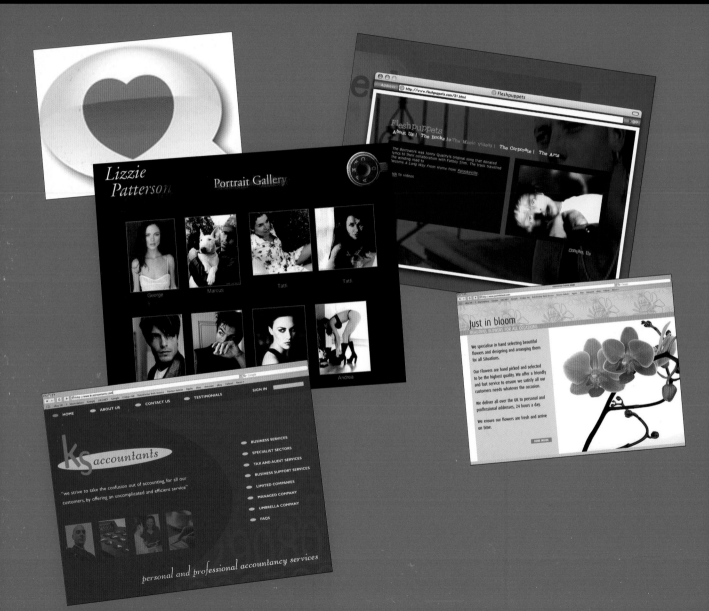

# WEB SITES

There are millions of Web sites in the world, and more individual Web pages than there are people on the planet. Web site designs are unusual in several respects: on the one hand, people establish long-term "relationships" with favored Web sites by visiting regularly for updates and the latest news. On the other hand, they might decide in a split second whether or not they want to visit that site again. If the site takes an age to download, if it is difficult to navigate or understand, or if the site makes information hard to find, then they may never visit again. Web site design is about balancing visual appeal with usefulness.

# Web sites: home business

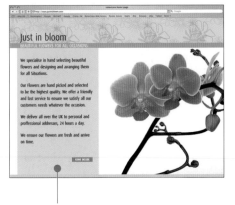

**A Web site is a global shop window for local businesses (many of which find entirely new markets online), and also an extra means for local people to use your services. So design it as both brand extension—and brand introduction.**

Wallpaper is a term that's come to mean a background graphic on a computer screen, as well as a physical sheet of paper. For this home business we've already designed a range of actual papers that use the floral graphic theme we've developed, so use it here as a decorative element that reinforces the "branded" approach. This is also a good opportunity to let the services—these beautiful flowers—speak for themselves. They are a visual flourish in a medium that is often very static and "blocky" in terms of the average standard of design.

### THE WEB SITE
A Web site should be easy to navigate and should "make sense" to the visitor the first time they click onto it. Grab visitors' attention quickly, and make them spend time on the site. Make it "sticky," as they say in the industry.

### THE HOMEPAGE
A simple homepage that's quick to load, easy to read, and invites the visitor in. That's all a homepage should do.

### A SIMPLE ENTRY BUTTON
Easy to make in any Web site design package, but a vital feature that visitors will voluntarily click...

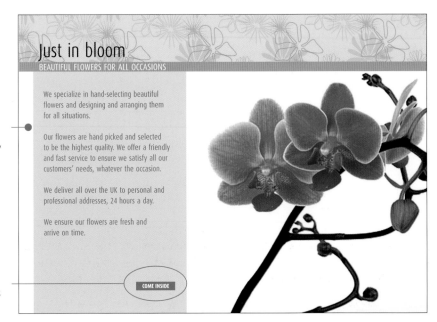

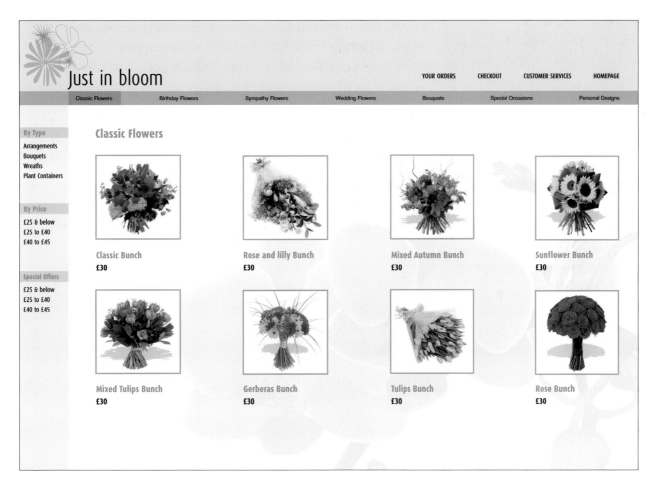

## Just in bloom

YOUR ORDERS    CHECKOUT    CUSTOMER SERVICES    HOMEPAGE

| Classic Flowers | Birthday Flowers | Sympathy Flowers | Wedding Flowers | Bouquets | Special Occasions | Personal Designs |

**By Type**
Arrangements
Bouquets
Wreaths
Plant Containers

**By Price**
£25 & below
£25 to £40
£40 to £45

**Special Offers**
£25 & below
£25 to £40
£40 to £45

### Classic Flowers

**Classic Bunch**
£30

**Rose and lilly Bunch**
£30

**Mixed Autumn Bunch**
£30

**Sunflower Bunch**
£30

**Mixed Tulips Bunch**
£30

**Gerberas Bunch**
£30

**Tulips Bunch**
£30

**Rose Bunch**
£30

## PAGE TWO
Now we get to the real meat of the site—the products and services. Keep these updated to maintain interest.

## FURTHER LINKS
Perhaps make some of these clickable so that the visitor gets more information, and perhaps a much larger image.

## MENU
A simple menu sets out the full range of services and obliges people to spend a bit longer looking at your site.

# Web sites: home business

**For visitors who are familiar with the company's services, this site clearly relates to existing visual material. Ensure, then, that your design strategy is built to last a few years so you don't have to redesign the Web site too quickly.**

We can see straight away that some elements of this design have to be thought about very carefully in terms of translating them to the computer screen—namely, the design theme of the white and tinted typographic elements being reversed out of the background color. This may mean rethinking the concept, or simply using it with extra care so that the type is sufficiently large onscreen and at a weight that makes it legible for people who many not have perfect eyesight.

### THE WEB SITE
This site is a simple, easily navigable site that acts as an online brochure—a one-off design that has a much longer shelf-life than a paper brochure or flyer.

### THE HOMEPAGE
A simple homepage doesn't have to mean no imagination or creative flair. Here, we've run some images in a tone of the main corporate color, and mixed entirely upper-case type with type set solely in lower-case letters to create extra impact and reinforce the logo.

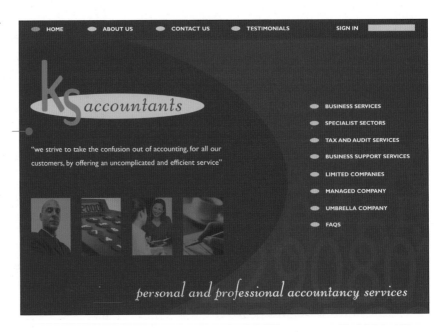

## PAGE TWO

The brochure-style approach extends to the limited menu and paired-down, factual approach to the content.

## FURTHER ELEMENTS

We've included the option for existing clients to sign in to get access to a more in-depth, privileged level of services.

## VIEWING PRODUCTS

Highlighting the small buttons in red makes a strong visual impression as it is the only use of another color here.

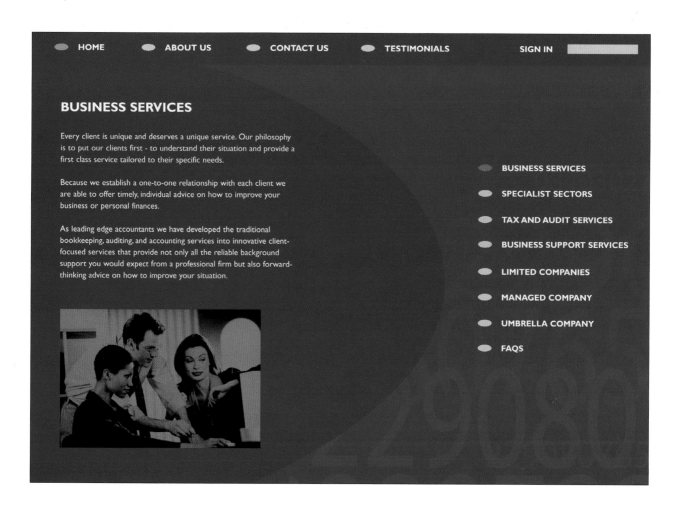

HOME    ABOUT US    CONTACT US    TESTIMONIALS    SIGN IN

### BUSINESS SERVICES

Every client is unique and deserves a unique service. Our philosophy is to put our clients first - to understand their situation and provide a first class service tailored to their specific needs.

Because we establish a one-to-one relationship with each client we are able to offer timely, individual advice on how to improve your business or personal finances.

As leading edge accountants we have developed the traditional bookkeeping, auditing, and accounting services into innovative client-focused services that provide not only all the reliable background support you would expect from a professional firm but also forward-thinking advice on how to improve your situation.

BUSINESS SERVICES

SPECIALIST SECTORS

TAX AND AUDIT SERVICES

BUSINESS SUPPORT SERVICES

LIMITED COMPANIES

MANAGED COMPANY

UMBRELLA COMPANY

FAQS

# 14 Web site strategies

**There are literally billions of Web pages on the Internet, which means billions of pieces of design—both good and bad. Here we feature some real Web sites that signpost just a few of the strategies you might like to explore yourself.**

There are a lot of theories about Web site design. The success of Google has led many people to believe that the best Web sites should be simple, clutter-free, and useful rather than crammed full of graphics, animations, and dozens of other elements that "shout" from the screen and demand your attention. Some homepages load in their entirety and give you menus and links, while others scroll downward and oblige you to interact with the first page. Always find out how quickly your page loads.

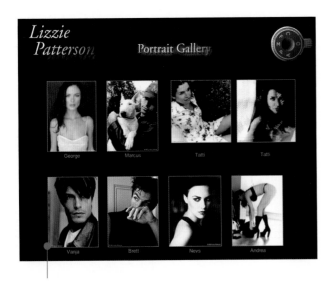

**A SIMPLE PORTFOLIO**
An understated approach that simply lets the work speak for itself.

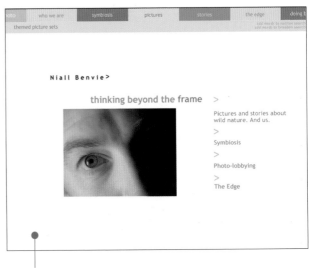

**MINIMALIST NAVIGATION-BASED**
A modern, color-coded approach that separates portfolio from homepage.

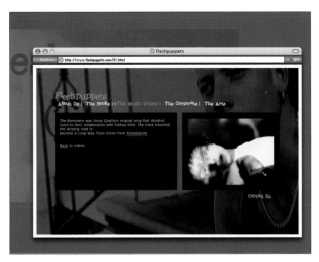

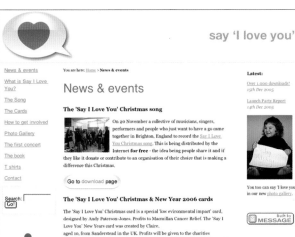

## OTHER APPROACHES

This videomaker's Web site (above left) just has a "wallpaper" for the homepage. Entering the site brings examples of work into a popup window using Flash technology. This Indian wedding service Web site (above right) uses traditional graphics and colors to create a "statement" homepage, before leading you into a menu of services and contacts. To find out more, you have to click on links embedded in the graphic elements. This is simple to do in your Web site design and building software.

## CLASSIC WEB DESIGN

Clean graphics, strong message, and a scrolling homepage for this charity.

# Graphics-based Web sites

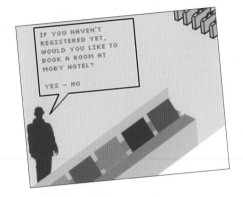

**Other Web sites are much more ambitious without necessarily being complex to design or create. Some people—many professional graphic designers and illustrators among them—design Web sites based predominantly on graphics.**

A portfolio Web site doesn't have to go the obvious route of displaying thumbnails of images in a "photo album" style. You can base your entire Web site design on a single visual element or concept, whether it is an example of your work, a child's painting, a photograph, and so on. You can even design your page so that work, such as a video, pops up and plays automatically, but some people (particularly those with older computers or dial-up connections) dislike such features as they play slowly.

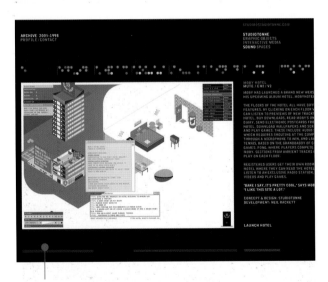

**CUTTING-EDGE GRAPHICS**
Futuristic graphics and navigation from this professional multimedia designer.

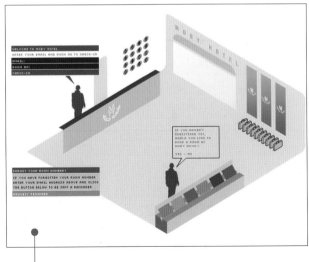

**IMAGE-BASED DESIGN**
Links embedded in a striking graphic on this musician's highly interactive site.

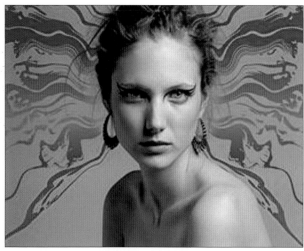

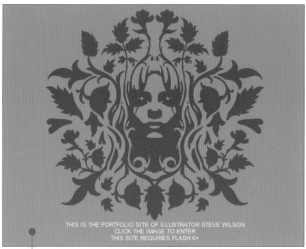

**PROFESSIONAL ILLUSTRATOR**
An example of a Web site as a showcase
for individual pieces of work.

# ENDMATTER

# Glossary

**Bit**
Short for "binary digit," the smallest piece of information that a computer can process.

**Bitmap**
Something—an image, or a typeface—that is composed of dots or pixels onscreen.

**Body text**
The main text in a printed book or magazine—as opposed to headlines, and so on.

**Browser**
A computer application that allows you to access and display Web sites and Web pages onscreen.

**CD-ROM**
Compact Disk Read-Only Memory. Popular disk format for storing data, such as text and images.

**CMYK**
Cyan, Magenta, Yellow, and blacK. The four-color printing system used to produce books and magazines.

**Compression**
Making digital files (such as images) smaller while not losing data that is vital to their quality.

**Digital**
Description of any device or process in which data is stored or modified using binary (computer) code.

**Download**
The transfer of data from a remote computer to your PC, or from your PC onto a disk or device.

**DPI**
Dots Per Inch, a calculation that measures the resolution of devices such as desktop printers.

**DVD**
Digital Video (or Versatile) Disk. Popular high-capacity disk format for data, such as images and video.

**Font**
Full set of typeface characters of the same size, design, and style. Font choice is vital to good design.

**Format**
In printing, the orientation or size of a page or publication. In data, the way in which it is saved.

**Graphic**
General description of an illustration- or drawing-based design, or design element.

**Grid**
In graphic design and publication design, the underlying structure that gives form to the page.

**HTML**
HyperText Markup Language. The text-based description language used to format Web pages.

**Hue**
Pure color on the color spectrum, i.e. all reds have the same hue, as do all blues, all yellows, and so on.

**Ink-Jet (Printer)**
Affordable desktop printer technology that sprays tiny jets of ink onto the surface of the paper.

### JPEG
Joint Photographic Experts Group. Popular compressed file format for bitmap images, such as photos.

### Kerning
The manual increase or decrease of the spaces in between individual letters in a piece of text.

### Layers
In Photoshop, invisible levels in which different image elements can be stored and edited separately.

### Leading
The vertical gaps between individual lines of text, which you can change as part of your design.

### Mac
Computer system developed and made by Apple Computer, which is different from Windows-based PCs.

### Megabyte (MB)
Description of file size. A Megabyte is one thousand Kilobytes. One Kilobyte is one thousand Bytes.

### PC
Personal Computer. Ubiquitous computers, mostly running Micosoft's Windows system.

### PDF
Portable Document Format. Format that allows documents to be sent electronically and viewed onscreen.

### Pixel
Short for Picture Element. The smallest element of a digital image, such as a dot of light onscreen.

### PPI
Pixels per Inch. Description of the resolution of either images or computer monitors.

### Resolution
Quality. High-resolution images contain more data, and are therefore of better quality.

### RGB
Red, Green, Blue. The three-color system used by computer monitors to display the illusion of full color.

### Rollover / Mouseover
Function within a Web page whereby an image changes when the mouse pointer moves over it.

### Serif
Ornamentation on the letter forms of some typefaces. Sans serif faces do not have these extra strokes.

### Software
Packages of computer code that enable your computer to carry out specific tasks or functions.

### TIFF
Tagged Image File Format. Popular graphics format used for bitmapped images at high quality.

### Tracking
The spacing between all of the letters in a line of text, which can be increased or decreased.

### Typography
The art of designing type, and of designing and arranging type on the printed page.

# Index

# Acknowledgments

**Luke Herriott**
I would like to thank my wife and Studio Ink partner, Becky, for her inspiration and creative input in developing and designing some of the projects in this book. A big thanks to Chris Middleton for conceiving the book and turning my rambling notes into readable English, and also to the rest of the RotoVision crew. Thanks to Rob Brandt and Rachael at the Electric Palace for allowing me to feature some of their work.

**Image credits (Projects)**
All work by Studio Ink  (luke@studioink.co.uk), except for:
*Rob Brandt*
p54, Tinysaurus nursery Logo; p77, Fine-line business card; pp114-115, wedding invitation; p135, Uden flyers; p139 Vive la Fip and Billion Dollar Brian flyers.
*The Electric Palace*
p54, Shot By The Sea and Electric Palace logos; p135, Electric Palace flyer.

**Credits (Introduction)**
The editor would like to thank David Dabner for his text and contributions to the introduction. Photography courtesy of students at the London College of Communication, used with the author's permission. Additional text (introduction and projects) by Chris Middleton.

# GUINNESS W🏛RLD RECORDS™

# DEADLY DISASTERS

## Catastrophic Records in History

Collect and
Compare with

# FEARLESS FEATS:
**Incredible Records of Human Achievement**

# WILD LIVES:
**Outrageous Animal & Nature Records**

# JUST OUTRAGEOUS!:
**Extraordinary Records of Unusual Facts & Feats**

# GUINNESS WORLD RECORDS

# DEADLY DISASTERS

## Catastrophic Records in History

Compiled by Celeste Lee & Ryan Herndon

For Guinness World Records:
Laura Barrett, Craig Glenday,
Dave Hawksett, Betty Halvagi

SCHOLASTIC INC.
New York   Toronto   London   Auckland   Sydney
Mexico City   New Delhi   Hong Kong   Buenos Aires

© 2006 Guinness World Records Limited, a HIT Entertainment Limited Company.

No part of this work may be reproduced, stored in a retrieval system, or transmitted in any form or by any means, electronic, mechanical, photocopying, recording, or otherwise, without written permission of the publisher. For information regarding permission, write to Scholastic Inc., Attention: Permissions Department, 557 Broadway, New York, NY 10012.

Published by Scholastic Inc. SCHOLASTIC and associated logos are trademarks and/or registered trademarks of Scholastic Inc.

ISBN 0-439-79193-6

Designed by Michelle Martinez Design, Inc.
Photo Research by Els Rijper and Daniella Nilva
Records from the Archives of Guinness World Records

12 11 10 9 8 7 6                                          10/0

Printed in the U.S.A.

First printing, February 2006

Visit Guinness World Records at www.guinnessworldrecords.com

# Contents

# A Record-Breaking History

The idea for Guinness World Records grew out of a question. In 1951, Sir Hugh Beaver, the managing director of the Guinness Brewery, wanted to know which was the fastest game bird in Europe — the golden plover or the grouse? Some people argued that it was the grouse. Others claimed it was the plover. A book to settle the debate did not exist until Sir Hugh discovered the knowledgeable twin brothers Norris and Ross McWhirter, who lived in London.

Like their father and grandfather, the McWhirter twins loved information. They were kids when they started clipping interesting facts from newspapers and memorizing important dates in world history. As well as learning the names of every river, mountain range, and nation's capital, they knew the record for pole squatting (196 days in 1954), which language had only one irregular verb (Turkish), and that

the grouse — flying at a timed speed of 43.5 miles per hour — is faster than the golden plover at 40.4 miles per hour.

Norris and Ross served in the Royal Navy during World War II, graduated from college, and launched their own fact-finding business called McWhirter Twins, Ltd. They were the perfect people to compile the book of records that Sir Hugh Beaver searched for yet could not find.

The first edition of *The Guinness Book of Records* was published on August 27, 1955, and since then has been published in 37 languages and more than 100 countries. In 2000, the book title changed to *Guinness World Records* and has set an incredible record of its own: Excluding non-copyrighted books such as the Bible and the Koran, *Guinness World Records* is the best-selling book of all time!

Today, the official Keeper of the Records keeps a careful eye on each Guinness World Record, compiling and verifying the greatest the world has to offer — from the fastest and the tallest to the slowest and the smallest, with everything in between.

# What Happened?

For 50 years, Guinness World Records has been collecting facts about the world's most amazing record-breakers. In this collection, we focus on catastrophic events in history. From natural to man-made, from the longest conflicts to the loudest eruptions — one event can change the world, and all of our lives.

Meet a survivor from the sinking of a supposedly unsinkable ship, outrace a whirling tunnel of wind in Tornado Alley, dig out from beneath an avalanche, clean up the water and its wildlife after an oil spill — these are a few of the stories of tragedy and triumph inside.

This book answers the difficult question of "*What happened?*" in the hope that some of these tragedies will never happen again.

# Chapter 1

## When the Earth Erupts

Mother Earth has awesome powers and doesn't need an appointment to surprise us. Sometimes, she shakes the ground, makes wild waves, or blows the tops off mountains. The planet Earth is moving and changing around us. All we can do is hang on.

# Highest Death Toll from a Tsunami

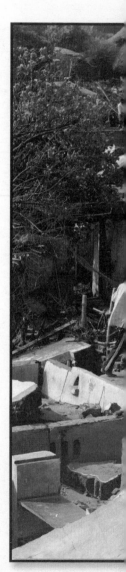

The **Highest Death Toll from a Tsunami** occurred on December 24, 2004, with up to 285,000 confirmed dead and more than 5 million homeless in at least 12 countries. A massive underwater earthquake near the island of Sumatra, Indonesia, caused the tsunami. This series of gigantic waves traveled outward from its epicenter across the Indian Ocean at jet speeds — up to 450 miles per hour. Such destructive power spread throughout southeast Asia, reaching 3,000 miles west to the eastern coast of Africa — Somalia, Kenya, and Tanzania. The energy unleashed is estimated to equal the detonation of 23,000 atomic bombs!

Bangladesh, India, Indonesia, the Maldives, Malaysia, Sri Lanka, and Thailand were among the worst hit. The presence of hundreds of coastal fishing villages meant a staggering number of lives and homes lost (pictured here and in the insert). Scientists believe few animals died because they sensed warning vibrations that humans cannot. People are setting up advance-warning systems to better prepare for nature's disastrous surprises. A full recovery will take years, yet the outpouring of worldwide support is tremendous (see Record 50).

# Tsunami Sources

Landslides, volcanic eruptions, under-water earthquakes, and, in rare cases, a meteoric impact with the ocean can cause a tsunami. A tsunami's most common source is an under-water quake. Earth's outer shell consists of shifting tectonic plates. One plate sliding beneath another creates tension, and this energy is released in an earthquake. Underwater quakes cause the sea floor to buckle and displace enormous volumes of water, resulting in destructive waves. Volcanically formed islands, such as the country of Japan and the state of Hawaii, are more likely to experience tsunamis than other places.

# Largest Modern-Day Volcanic Explosion

Although Kilauea is the **Most Active Volcano** (see the front cover), an older volcano is still the more famous record-holder. On August 26, 1883, the island volcano of Krakatoa in modern-day Indonesia (locally known as "Krakatau") blew itself into history as the world's **Largest Modern-Day Volcanic Explosion**. Formed when the Indian-Australian plate slid underneath the Eurasian plate, the volcano had not erupted for more than 200 years. Four intense explosions caused a 131-foot-high tsunami that hit 163 coastal villages and killed 36,380 people.

People worldwide experienced the effects of this VEI (Volcanic Explosivity Index) level 6 explosion. Level 6 is considered "colossal." The force was 10,000 times that of the Hiroshima atomic bomb, and the world's climate did not return to pre-event temperatures for 5 years. Pumice was thrust 34 miles up into the stratosphere (see illustration). Ash fell for 10 days, drifting on air currents 3,313 miles away from the volcano. Tsunami waves were seen as far as the West Coast of the United States, South America, and the English Channel in Europe.

# Another Big Bang

The eruption of Krakatoa was also the explosion heard around the world. People in Australia and even as far as Rodriguez Island in the middle of the Indian Ocean heard this big bang — that's 2,968 miles away or 1,000 miles east of Madagascar! Because it takes time for sound to travel, the people on Rodriguez heard it four hours after the initial eruption and thought it sounded like the distant roar of cannons firing. This extraordinary example of sound travel also makes Krakatoa's eruption the Loudest Noise Heard by Humans in recorded history.

# Greatest Recorded Climactic Impact of a Volcanic Eruption

Among the 13,000 islands of Indonesia are 76 historically active volcanoes. The 1815 eruption of the Tambora volcano on the island of Sumbawa (pictured) resulted in a global temperature drop of 5.4° F and ultimately caused the deaths of 92,000 people. This is the **Greatest Recorded Climatic Impact of a Volcanic Eruption**. The volcano was estimated to have been 13,000 feet high prior to the eruption — the present-day volcano crater, or caldera, is 3,640 feet deep. Therefore, Tambora yielded 150 times the explosive power of Mount St. Helens' eruption (see Record 4). The year 1816 became the famous "year without a summer" in Canada, New England, and Western Europe. Crop failures hurt food supplies in Europe and India.

# Largest Modern-Day Landslide

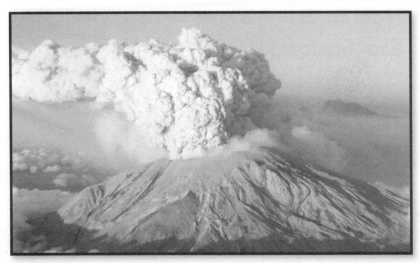

In March 1980, hundreds of minor earthquakes were recorded at the previously dormant Mount St. Helens in Washington State, USA. By the end of April, the swollen mountain had a gigantic bulge on its north face, likely caused by pulsing magma. The week prior to the actual eruption saw at least eight earthquakes daily, measuring greater than 4.0 on the Richter scale. At 8:32 A.M., on May 18, 1980, a 5.1 quake directly beneath the north face caused the **Largest Modern-Day Landslide**. The landslide loosened the pressure on the magma. Within seconds, the volcano itself erupted (pictured), and the mountain set another Guinness World Record when the **Fastest Avalanche** began. Lasting for an estimated 20 seconds, approximately 96,000 million cubic feet of rock slid off the mountain's north slope, across Spirit Lake, and down to Tousle River at a velocity of 110–155 miles per hour.

# Worst Devastation Due to an Earthquake

Historically, Japan has encountered more earthquakes than Indonesia. On September 1, 1923, just before noon, a catastrophic earthquake (8.19 on the Richter scale) hit the Kanto Plain (near the modern city of Tokyo). Nearly all buildings at that time were made of wood. An estimated 575,000 dwellings were destroyed. Numerous fires started from people cooking lunch on charcoal stoves. A nearby typhoon's high winds spread the flames. Ruptured water mains could not extinguish the fires for days. Tokyo had 3 million people and nearby Okolona port city had 423,000 people. Official numbers listed 142,807 missing or killed. Both cities were damaged and millions became refugees in the **Worst Devastation Due to an Earthquake** (pictured).

# Quake Ratings

Seismometers measure an earthquake's vibrations. The Richter scale, devised in 1934 by scientist Charles F. Richter, is a logarithmic scale used worldwide to rate a quake's destructive power by amplitude (1-10) and magnitude class (from minor to great). Whole number shifts on the scale, from a level 1.0 to a 2.0, means the amplitude increases by 10 times. The majority of earthquakes are "microquakes" of 2.5 or less, undetectable to humans. A "great" quake, of 8.0 and above, can topple cities near its epicenter. The energy released is equal to detonating 6 million tons of dynamite. The Sumatra-Andaman Islands earthquake in the Indian Ocean on December 26, 2004, had a magnitude of 9.1 - 9.3!

# Chapter 2
## Wind and Water

Nature is clever, creative, and often invisible to the unaided eye. You normally can't see air, but you can see the homes and lives ruined by wild windstorms such as tornadoes and hurricanes. Wind sent by the sun has also generated a unique storm on our planet. Then there's a lake that must be burped, or its invisible gases can kill. Hold your breath!

# Most Tornadoes in 24 Hours

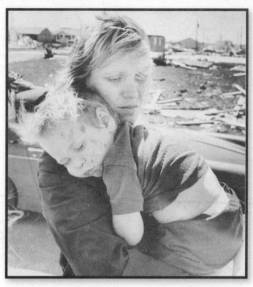

An unimaginable 148 twisters swept through Tornado Alley on April 3–4, 1974, making history as the **Most Tornadoes in 24 Hours** ever recorded. "Tornado Alley" is the windstorm-producing climate zone ranging from central Texas to Iowa and Nebraska. The 1974 "Super Outbreak" traveled across 13 states (Alabama, Georgia, Illinois, Indiana, Kentucky, Michigan, Mississippi, North and South Carolina, Ohio, Tennessee, Virginia, and West Virginia). A total 330 lives were lost, with 5,485 reported injuries in a damage path of 2,500 miles. Families, such as this mother and daughter, lost their homes to the savage winds (pictured). Today, the National Weather Service issues tornado warnings with an average lead time of 11 minutes — long enough to save more lives.

# Worst Homeless Toll from a Cyclone Disaster

Hurricane Mitch formed in the southern Caribbean Sea on October 21, 1998. By October 26, Mitch had strengthened from 60 to 155 knots. The now-catastrophic Category 5 hurricane struck Honduras and Nicaragua between October 26 and November 4, 1998. Its heavy rains caused flooding and mudslides. The storm killed 11,000 people, destroyed 93,690 dwellings, and left around 2.5 million people dependent on international aid. This marked the **Worst Homeless Toll from a Cyclone Disaster** (pictured).

## Naming the Wind

Storm names are different around the world. In America, *cyclones* are typically called *hurricanes*. In Hong Kong, this storm is called a *typhoon*; in Haiti, it is a *taino*. Storm intensity also changes the terms. *Tornadoes* are land-based wind funnels. Over water, such a windstorm is formed by a *tropical depression* that spins into a *tropical storm*. This storm graduates to *hurricane* levels — and is named by the National Hurricane Weather Service — when its spiraling wind speeds exceed 74 miles per hour.

# Worst Monsoon

The **Worst Monsoon** raged throughout Thailand from September to December 1983 (pictured). Up to 100,000 people contracted waterborne diseases. An estimated 15,000 were evacuated and 10,000 died.

Monsoons are dramatic weather disturbances that occur seasonally in southern Asia, Australia, India, and Africa. During summer, the land heats up and cools down faster than the surrounding ocean water. Displaced air rises over land and causes a low-pressure area. Since wind naturally blows from areas of high pressure to areas of low pressure, an extremely strong and constant wind blows from the ocean onto the land. This wind triggers intense rainfall. The wind and the water combine into a hazardous weather condition called a *monsoon*.

# Some Rain Is Good

The next time you wish it would stop raining, think of these events during the years of 1876 through 1879. The Worst Drought Famine occurred in northern China after the rains failed to fall for three consecutive years: Between 9 and 13 million people were estimated to have died. Five million other people died during the same period because the monsoon failed to arrive in India.

# Most Destructive Geomagnetic Storm

On March 13, 1989, our planet Earth experienced its **Most Destructive Geomagnetic Storm** (see illustration). This rare event generated by our sun disrupted North America's power grid, including suspending electricity in Quebec for 9 hours and altering the orbits of satellites. A geomagnetic storm occurs when a superpowerful solar wind penetrates Earth's protective radiation belts (called Van Allen belts) and causes a severe distortion of our planet's magnetic field (a *magnetosphere*). Such storms typically last from one to two days and can increase radiation levels on Earth. Fortunately, our atmosphere and magnetosphere provide adequate protection, but you might not survive if you were an astronaut on the moon wearing only a spacesuit!

# Deadliest Lake

Have you ever gone swimming in a lake? Avoid Lake Nyos in Cameroon, West Africa, known as the **Deadliest Lake** (pictured). On the seemingly normal night of August 26, 1986, a massive amount of carbon dioxide ($CO_2$) burst from Lake Nyos and formed a poisonous cloud over the area. Deprived of oxygen, thousands of animals and 1,746 people died. Scientists have since determined that a dormant underwater volcano released the gas. Because it was trapped at the lake's bottom, the gas reached toxic levels before its release on that fateful night.

# Chapter 3
## Fire and Ice

Neither too much heat nor too much cold is good for us. Mastering fire gave us the ability to mold metal, but if we lose control of this dangerous element, it can cause great destruction. We are also at nature's mercy when it comes to ice, wind, and snow, especially if our homes are at the foot of a mountain.

# Largest Damage Toll from a Fire Disaster

The Great Earthquake woke up San Francisco at 5:12 A.M. on April 18, 1906. It was an 8.25 Richter scale trembler and lasted for 49 seconds (see a photo of the quake damage in the special insert). As bad as it was, the worst was yet to come.

Broken water mains and several small fires gaining in strength and speed set off a catastrophe. Fires consumed the city for more than three days and spread over 8 square miles of land (pictured). Firefighters and citizens worked heroically to stop the fire's path, and eventually succeeded, but it was the **Largest Damage Toll from a Fire Disaster**. An estimated 3,000 lives were lost, with 28,000 buildings in cinders, leaving 225,000 people homeless. The amount of damage and destruction to the young city was staggering and, in today's dollars, equivalent to more than $5 billion!

# Money on Fire

The San Francisco earthquake also caused gas mains to twist and break. Leaking gas from the mains started the fires. This, combined with wood construction throughout the city, created a recipe for disaster. At 10:00 A.M., American soldiers dynamited strategically positioned buildings in an unsuccessful attempt to save the U.S. Mint building. Throughout the second day of the fires, city authorities would not allow buildings to be blasted in advance unless the fire was already at the door. When the fire outflanked fire-fighters, entire city blocks were then dynamited in advance of the fire's greedy path to create firebreaks. The strategy worked. Yet "the Great Fire" consumed at least 500 city blocks, including the treasury building, and would have destroyed the entire city if not stopped by such drastic methods.

# Most People Trapped in an Avalanche Disaster

On January 20, 1951, hurricane-force winds shaped two different layers of snow — powdery with wet and heavy — into a series of avalanches that engulfed the Swiss, Austrian, and Italian Alps. The **Most People Trapped in an Avalanche Disaster** was an extraordinary 45,000 people! A total 240 people died. The villagers of Vals, Switzerland, honored those lost with wreaths (pictured). Avalanches have been recorded in the Swiss Alps since the year 1302. By the 14th century, locals learned that they must care for the surrounding forests that, in turn, protected their villages from the most devastating effects of these high-velocity avalanches.

# Most Celebrated Canine Rescuer

Are dogs truly our best friends? A St. Bernard named Barry certainly was a special dog. He rescued at least 40 people during a heroic 12 years serving as the **Most Celebrated Canine Rescuer** of the Swiss Alps. One of his most famous rescues was when he found a boy half frozen under an avalanche in which the boy's mother had already died. Barry spread himself across the boy, using his heavy furry body to warm him, and licked the boy's face until he awoke. Then he carried the boy on his back to safety! St. Bernard dogs were originally bred to be herders, but monks in the treacherous Swiss Alps soon realized that this breed's superior sense of smell, body strength, perfect sense of direction, and thick, weather-resistant coat made them man's best rescuers (pictured).

# Worst Snowstorm Disaster

The **Worst Snowstorm Disaster** slammed the entire eastern seaboard of the USA on March 12 and 13, 1993. In New York State alone, 40 inches of snow fell. Farther south, 60 inches — that's 5 feet — piled up in the Appalachians along the Tennessee/North Carolina border. Blustery winds stronger than 70 miles per hour bowled people over, and drifts rose higher than 20 feet. Many people were snowed inside of their homes. Alabama received 13 inches, and 5 inches of snow fell on sunny Florida, records for both states. The blizzard's fury cost 500 people their lives during those two days now known as "The Storm of the Century" (pictured).

# Worst Damage Toll from an Ice Storm

For six days in early January 1998, a stunning storm draped eastern Canada and the northeastern United States with ice up to 4 inches thick (pictured). Blackouts ensued, travel halted, and communications were interrupted as the weight of the thick ice broke trees, power lines, and even transmission towers. In the Canadian provinces of Ontario, Quebec, and New Brunswick, power was out for a full month in many places. It was the most expensive natural disaster ever in Canada and affected millions of people. The **Worst Damage Toll from an Ice Storm** amounted to about $650 million.

# Chapter 4
# Hazardous to Your Health

Some of mankind's biggest enemies have been too small to be seen . . . except by a microscope. Bacteria sickened the feudal society of Medieval Europe. A virus caused the deadly flu epidemic of 1918. Many microscopic hazards result in worldwide death tolls, such as the Ebola virus, a malaria-causing parasite, and common tobacco smoke. Learn about what to avoid and why!

# Worst Pandemic

A disease outbreak that spreads quicker than anticipated is an *epidemic*. An infection affecting several countries is a *pandemic* (see illustration).

The Black Death of the Middle Ages was the **Worst Pandemic**, claiming somewhere between a quarter and a half of the entire population of Europe. At the time, no one understood viral infections or disease transmissions. Families, friends, doctors, and government abandoned one another in fear of being infected. Approximately 75 million people died worldwide between 1347 and 1351 from infections of the bubonic and pneumonic plagues. Today, we know bacteria generated both plagues. There are still a few cases each year, but antibiotics cure the infected.

# Deadly Transmission

How the bubonic plague was transmitted:

1. Fleas drink rat's blood, which carries the bacterium.

2. Bacteria (*Yersinia pestis*) multiply rapidly in the flea's stomach.

3. Bacteria clog up the flea's stomach, making it feel hungry.

4. Flea bites human and regurgitates infected blood into human.

5. Human is infected, and the flea dies of starvation.

Flip to the special color section for a microscopic view of the deadly bacteria.

# Most Dangerous Parasite

Malaria is a tropical disease that is curable, if treated quickly. Humans have recorded the disease for more than 6,000 years. The **Most Dangerous Parasite** is of the genus *Plasmodium*, of which there are four different species — only one carries the virus. The parasites first infect female anopheles mosquitoes, who then bite humans and pass the disease. Did you know there are 2,500 different kinds of mosquitoes in the world (pictured)? Only 30 anopheles species carry malaria. Each year, there are 220 million new infections, of which less than 2 percent are fatal. However, it is believed that *half* of all human deaths (not including wars and accidents) have been caused by this invisible single-cell parasite since the Stone Age.

# Worst Influenza Epidemic

RED CROSS WORKERS SUCCEED
IN MEETING HEAVY CALLS FOR
AID IN BATTLE ON INFLUENZA

Women of Mother Kind Still Urgently Needed for
Service in Stricken Homes; Mask Profiteers Scored;
Street Expectoration to Be Severely Punished

OPEN AIR AND
VACCINE WILL
FIGHT DISEASE

300,000 Cases in State Are
Feared Unless Patients Kept
in Uncovered Hospitals

Unless more drastic precautionary
measures are taken and open-air hos

The common flu is a lethal illness. From 1918–1919, the so-called Spanish Flu Pandemic spread havoc globally and killed 21,640 million people. In the United States alone, more than 600,000 died by the time the **Worst Influenza Epidemic** ended (see newspaper article). It was said that every family lost someone during its 10-month reign. Most American doctors were in Europe supporting World War I efforts. Scientists did not yet know much about viruses. The optical microscope revealed bacteria, and scientists tried to create a vaccine. With the invention of the electron microscope, scientists finally could see viruses, which are many times smaller than bacteria.

# Most Virulent Viral Disease

Ebola hemorrhagic fever, usually known simply as Ebola, is the **Most Virulent Viral Disease**, causing death in up to 90 percent of cases. While the exact origin of the disease is unknown, cases have been seen in humans since the 1970s throughout Africa, including 318 people in Zaire in 1976. There is no cure yet, and this horrible illness causes high fevers and bleeding from eyes, ears, and nose. Fortunately, the disease is extremely rare; less than 1,500 people have contracted Ebola. Infected animals transmit the virus to humans. Experts believe once the animal source is discovered that it will be fairly easy to halt transmission to humans. Members of the Centers for Disease Control and Prevention (CDC) must wear protective suits when investigating an outbreak (pictured).

# Most Urgent Health Problem

The World Health Organization (WHO) estimates that by the year 2020, tobacco-related illnesses including heart disease, cancer, and respiratory disorders will be the world's leading killer, responsible for more deaths than AIDS, tuberculosis, road accidents, murder, and suicide combined. Globally, 1.1 billion people smoke, and of those smokers, 500 million people alive today will die of smoking-related illnesses. In America alone, 53 million people smoke. Side effects include shortness of breath, racing heart rates, and reproductive problems. Because passive smokers — people who inadvertently breathe in other people's smoke — are also affected, the potential for tobacco-related disease is the **Most Urgent Health Problem**, with 12,000 people in the USA dying from tobacco-related illnesses — every day!

## Calling Doctors

Need to see a doctor quickly? Let's contrast the cities holding the records for Most and Least Amount of Doctors. Your best bet is in Monaco where there is one doctor for every 170 people. In Malawi, however, there is only one doctor for every 49,118 people!

Monaco

Malawi

# Chapter 5
## On Land and Sea

Modern life brings great convenience — fast transportation and electricity to power our lives. But it also brings the potential for disaster, often caused by improper use of technology or disregard for safety precautions. We'll look back at a nuclear reactor leak caused by human error, a mysterious train wreck, a fateful tunnel trip, and an almost-forgotten yet devastating steamboat accident at the end of America's Civil War.

# Worst Nuclear Reactor Disaster

Nuclear energy is clean energy that doesn't require finding more fossil fuels, yet accidents endanger lives and the environment. On April 26, 1986, Chernobyl No. 4 nuclear reactor in the former U.S.S.R. experienced the **Worst Nuclear Reactor Disaster** due to a disregard of safety procedures and a badly designed reactor (pictured). A chain reaction generated steam explosions and a fire blew off the reactor's concrete and steel lid, releasing five percent of the radioactive core into the sky. Most of the material landed nearby as dust and debris. Wind carried some of the lighter materials to what is now Ukraine, Russia, Belarus, Scandinavia, and Europe. While only 31 people died, mostly heroic firefighters who gave their lives to end the radioactive fire, countless others were affected by the radiation leak (see the special color insert). Today, Chernobyl remains uninhabitable.

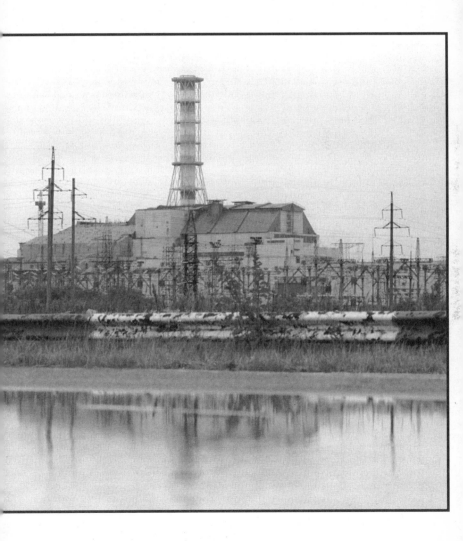

## Worst Train Disaster

On June 6, 1981, the **Worst Train Disaster** claimed the lives of more than 800 passengers when a train plunged off a bridge into the Bagmati River at Samastipur, in Bihar, India (pictured). The train had seven coaches and was traveling at full capacity. Some reports put the death toll as high as 1,000. To this day, there has never been a satisfactory explanation as to the exact cause of the accident — many believe the train struck a water buffalo on the line. Others believe that the train's brakes failed or a storm suddenly occurred. Sadly, only 212 bodies were ever recovered from the river.

# Worst Subway Disaster

Generally, trains are an efficient, economical, and safe mode of transportation. In the USA, there are less than four accidents per million freight and passenger miles, and most of these are minor. The key to train safety is maintenance and timely improvements of tracks, signals, and locomotives (pictured).

With the Industrial Revolution came the growth of big cities. But the density of population made it hard to get around. London built a subway before any other city — beginning in 1863 — and still has one of the most extensive systems in the world. New York City wasn't far behind — its first subway rolled out in 1904. Riding the subway is efficient, fast, safe, and inexpensive! The chance of an accident is far less than in a car.

Yet in Azerbaijan's capital city, Baku, a subway train caught fire in a tunnel between stations, killing 300 people and injuring hundreds in the **Worst Subway Disaster** on October 28, 1995 (pictured).

# Worst Single Ship Disaster

April, of the year 1865, marked a tragic month in American history. On April 9, General Robert E. Lee's surrender ended the devastating Civil War. President Lincoln was assassinated on April 14. Then at 2:00 A.M., on April 21, the steamboat *Sultana* sank in the Mississippi River near Memphis, Tennessee, USA, in the **Worst Single Ship Disaster**. More than 1,650 lives were lost out of 2,300 passengers. The majority were Union soldiers, recently freed from Confederate prisons, on their way home (pictured). The boat had a legal capacity of 376 people, and a badly patched boiler failed. Dangerous overcrowding and poor repair sank the *Sultana*. Similar situations contributed to the sinking of a far more famous ship (see Record 35).

# Worst Road Accident

**Today's tunnels are built using advanced boring machines and are extremely safe. It took only 3 years to finish the 31-mile underwater chunnel between England and France (see map). It is comprised of two full-size tubes for trains, with a special service tube in between that can also be used as an escape route! In 1996, 31 people used the service route successfully during a train fire.**

Tunnels are a feat of modern engineering. Soviet engineers built the Salang Tunnel in Afghanistan, north of the capital, Kabul, in 1964. The 1.86-mile-long tunnel crosses the Hindukush mountain range — linking the north to the south year-round, and reducing travel time from 72 to 10 hours. Salang is the world's highest tunnel at 11,036 feet, and 1,000 vehicles safely pass though it daily. Unfortunately, the tunnel was also the site of the **Worst Road Accident** on November 3, 1982. According to official Afghan records, 176 people died when a gas tanker exploded. No one is certain what happened, but the explosion was likely caused by a collision between the tanker and a convoy of Soviet troop vehicles.

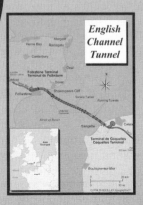

*English Channel Tunnel*

# Chapter 6
# In Air and Space

Humans have always wanted to fly. Today, we can soar faster, higher, and farther than our feathered friends. Usually this transportation mode is safe. However, when mistakes happen, we learn from them and make improvements in our transportation systems. Here's a look back at mishaps aboard supersonic jets and space stations.

# Worst Single-Aircraft Accident

From Leonardo Da Vinci, whose notebooks revealed a fascination for mechanical wings, to the Wright Brothers at Kitty Hawk, humans have wanted "wings." Today, airplane travel is a daily, scheduled commuter activity. Modern jets are highly complex works of engineering — and are considered safer than cars. Some believe that planes are 22 times safer than cars on a per-mile basis. But tragedies still occur (pictured). The **Worst Single-Aircraft Accident** took place on August 12, 1985, when a Japan Airlines Boeing 747 crashed into the mountainside of a village 60 miles outside of Tokyo. The cause was a faulty repair that eventually resulted in a metal bulkhead failing. Although 520 passengers and crew died, four people survived, including a 12-year-old girl found in a tree!

# Worst Midair Collision

Collisions between airplanes are rare, due in large part to the efforts of the FAA (Federal Aviation Administration) and the ICAO (International Civil Aviation Organization). Regulations demand pilots maintain adequate distance between aircraft, both laterally and vertically. The horizontal distance between planes must be at least 5.75 miles, and the vertical distance a minimum of 1,000 feet. However, accidents do happen (pictured). The **Worst Midair Collision** occurred near New Delhi, India, on November 12, 1996. A Saudi Boeing 747 passenger plane collided with a Kazakh Ilyushin 76 cargo plane. The Kazakh plane had descended below its assigned height. Although there were no land casualties, all 351 passengers died.

# Worst Disaster Involving a Supersonic Aircraft

Supersonic means any speed faster than the speed of sound (761 miles per hour). Mach 1 is 761 miles per hour, and multiples of that represent different speeds. The Concorde jets were passenger aircraft able to travel at Mach 2.2 (1,450 miles per hour). Starting in 1977, Concorde flew transatlantic flights from London and Paris to New York City. Flight trips lasted only 3 hours 30 minutes, about the same travel time for a train trip between New York City and Washington, DC!

The **Worst Disaster Involving a Supersonic Aircraft** happened at Charles de Gaulle Airport in Paris, France, on July 25, 2000 (pictured). An overlooked piece of metal left on the runway punctured a tire of Concorde flight 4590 during its takeoff. The resulting tire blowout caused a fuel tank rupture. Fire rapidly led to multiple engine failure. The plane crashed just 60 seconds after takeoff into a nearby hotel. Four people on the ground, and all 109 people aboard the plane died.

# Worst Spacecraft Disaster

During the Cold War, space exploration was a fierce competition between the USA and the U.S.S.R. In 1957, the Soviets launched the first space satellite, *Sputnik*. Cosmonaut Yuri Gagarin became the first man in space on April 12, 1961. In 1968, the USA sent its three-man *Apollo* capsule around the moon. The next year, American astronauts Neil Armstrong and Buzz Aldrin made a lunar landing *and* walked on the moon. Yet the high risk factor of

space exploration has resulted in tragedy. The **Worst Spacecraft Disaster** occurred in the U.S.S.R. on October 24, 1960. An R-16 rocket exploded, and a two-day fire raged at the Baikonur Space Center, causing the deaths of 91 people. Today, the Baikonur Cosmodrome in Kazakstan is still a launching pad for space missions, such as international crews blasting off for the Mir space station (pictured).

# Greatest Spacecraft Collision

Astronauts seek to improve life on Earth and beyond. In 1986, the Soviet Union launched the first part of the Mir space station (pictured fully in the color insert). The **Greatest Spacecraft Collision** involved *Progress*, an unmanned Russian supply craft, and Mir during a docking test on June 25, 1997. After the collision, with the power out, American astronaut Michael Foale experienced the universe in complete silence. He later said, "It struck me just how small humankind is, trying to do what it's doing, but how great we are in attempting it." Although no one was seriously hurt, the station began depressurization. The international crew repaired the hole to remain in space for 3 more months! Foale and the two Russian cosmonauts, Alexander Lazutkin and Vasily Tsibliyev, transmitted this smiling image from Mir to Moscow's Mission Control Center on July 20, 1977 (pictured).

# Chapter 7
## Beating the Odds

Disasters can happen to anyone at any time — be it on vacation, sailing to a new country, enjoying a favorite sport, or simply minding one's own business on a windowsill. The following people — and a determined feline — survived some incredibly shocking events by luck, skill, and sheer force of will.

# Greatest Percentage of Burns to Body Survived

David Chapman survived an extraordinary level of burns following a fuel canister explosion on July 2, 1996 (not pictured). Ninety percent of his body was burned. In 36 hours, a team of burn treatment specialists (such as the one pictured) had removed the damaged skin. Family members donated skin grafts, and Chapman survived multiple surgeries that kept him in an operating room for 7 hours every other day for a full two weeks. The skin grafts worked for the record-holder of **Greatest Percentage of Burns to Body Survived**. Chapman was only 16 years old at the time of the accident.

# Most Deaths on Mount Everest in One Day

Climbing the world's highest mountain is a dream for many, yet an intense challenge even for the most experienced climber. Mount Everest was formed 60 million years ago and is still growing at 29,035 feet high. This altitude of 5.5 miles above sea level juts it into the "jet stream." Every year, people die in the attempt to conquer the mountain famous for avalanches, sudden weather changes, and a challenging terrain. The worst period was when a total of 98 climbers reached the peak throughout the year 1996, only for 15 to die during the descent. The **Most Deaths on Mount Everest in One Day** was May 10, 1996. A late-afternoon blizzard left climbers stranded near the peak — 8 never made it home (see the sidebar).

## Weathering Nature

A Nepalese pilot saved stranded climbers on Mount Everest in the highest helicopter rescue recorded. Among the survivors was Dr. Seaborn "Beck" Weathers (pictured) from Dallas, Texas. Frostbite claimed his right hand and part of his nose, but he lived to tell his chilling tale. Surviving 40°-below-zero temperatures and twice left for dead by rescue teams, Weathers made it down to the uppermost camp . . . after waking up from a hypothermic coma!

# Longest Post-Earthquake Survival by a Cat

Taiwan lost 2,400 people during an earthquake on September 21, 1999, that measured between 7.3 and 7.6 on the Richter scale. The general belief is that a survivor has only a 48-hour window in which to be found alive. But lucky survivors of all kinds beat the odds. Rescue workers found two brothers alive after 5 days 6 hours in their Taipei apartment. Two dogs were found alive in Puli — 13 days later! The **Longest Post-Earthquake Survival by a Cat** came by an unnamed feline who was found alive an astonishing 80 days post-quake in Taichung. Although the cat was barely breathing and dehydrated, a TV reporter rushed it to a veterinary hospital, where it was put into an incubator and fed with a syringe. This lucky cat made a full recovery (pictured)!

# CAUSED BY NATURE'S POWER . . .

© Warren Faidley/Oxford Scientific Films

**TWISTER SCALE**
In 1971, T. Theodore Fujita introduced the Fujita Scale, a ranking system of tornado intensity. Classifications are made after a twister leaves the area. F0 is "light damage" while F6 is "inconceivable damage." Wade into "Wind and Water" for more storm records.

# OR BY MANKIND'S MISTAKES

© John S. Lough/EVOSTC

### SPOILED BY A SPILL
The Exxon *Valdez*'s oil spill polluted Alaska's pristine waters and generated closer monitoring of all oil tankers to prevent a repeat of this tragedy. Witness the price the environment has sometimes paid in "Nature Suffers."

GUINNESS WORLD RECORDS ™

# THESE DEADLY DISASTERS

## TOPPLED CITIES

© Corbis

### TORN ASUNDER

The Great Earthquake of 1906 almost wiped out the city of San Francisco. The quake split buildings, and the resulting fires consumed most others. Dig into "When the Earth Erupts" and investigate "Fire and Ice" for nature's impact upon civilization.

# SADDENED GENERATIONS

© Gleb Garanich/Reuters/Corbis

## CANDLES OF COMFORT

Danger may not be seen, but grieving families always feel its effects. The radiation leak caused by the nuclear reactor accident at Chernobyl killed 31 people, sickened residents, and evacuated towns. Travel through "On Land and Sea" to learn more.

# FORGED HEROES

### "ABANDON SHIP!"

The order every sailor and passenger dreads hearing was given aboard the R.M.S. *Titanic* in 1912. During such tragic times, people have made heroic choices to save others. Hear from real-life survivors in "Beating the Odds."

GUINNESS WORLD RECORDS™

# REVOLUTIONIZED SCIENCE

© CNRI/Phototake Inc./Alamy

© NASA TV/AP Wide World Photos

## IN HERE AND OUT THERE
Disasters do create scientific breakthroughs. Antibiotics can cure those infected by *Yersinia pestis* in "Hazardous to Your Health." International space crews learned to work together after a collision depressurized the Mir space station "In Air and Space."

GUINNESS WORLD RECORDS ™

# MADE HISTORY

© Joseph Sohm/Visions of America/Corbis

**FOREVER REMEMBERED**
Once, the World Trade Center's twin towers provided a magnificent backdrop for the Statue of Liberty. Read about one fateful morning, and other life-changing events, in "Acts of War."

GUINNESS WORLD RECORDS™

# INSPIRED NATIONS

© Chaiwat Subprasom/Reuters/Corbis

© Greg Baker/AP Wide World Photos

### LEND A HAND
Communities must rebuild after a catastrophe strikes. The aftermath of the 2004 tsunami saw elephants moving objects too heavy for human hands and worldwide donations of clothing, food, and money. Heed the call to help others in "Rising to the Challenge."

# . . . TO BE A GUINNESS
# WORLD RECORD-HOLDER

# Highest Fall Survived Without a Parachute

On January 26, 1972, flight attendant Vesna Vulovic survived a 33,333-foot fall inside the tail section of a crashing DC-9 airplane. That's more than 6 miles! The Copenhagen (Denmark) to Zagreb (Croatia) flight exploded from a bomb planted by a Croatian political terrorist group. The situation was thought impossible to survive, but somehow the 22-year-old was found alive and in a coma. She suffered a fractured skull, broken vertebrae, and broken legs. Even more miraculously, the record-holder for **Highest Fall Survived Without a Parachute** made a full recovery and continued to love flying (pictured).

# Youngest *Titanic* Survivor

The "unsinkable" R.M.S. *Titanic* sank after colliding with an iceberg on its maiden voyage from England en route to America. (See the special insert for an illustration of this tragic sea voyage.) Not enough lifeboats for passengers and crew meant women and children had first priority. Millvina Dean was 9 weeks old when tragedy struck. Her father, Bertram, got the family up onto the top deck from their third-class steerage accommodations and put his daughter, wife, Georgetta, and son, Bertram, Jr., into lifeboat No. 13. He, like many of the men aboard, did not survive. The family had been emigrating to Kansas, but the mother returned to England. Dean had no knowledge of the event until, at 8 years old, her mother revealed her father's heroism, making her the **Youngest *Titanic* Survivor!** In April 2005, the now 93-year-old survivor had a double-decker bus in Southampton, England, named after her (pictured).

Here are some details about the famous ship:

• **Length of Ship** — 882 feet 9 inches

• **Gross Tonnage** — 46,329 tons

• **Rivets** — 3 million

• **Decks** — 7

• **Total Capacity** — 3,547 passengers and crew, fully loaded

• **Departure** — April 10, 1912, at 12:15 P.M. from Southampton White Star dock

• **On Board** — 2,223 passengers

• **Iceberg Collision** — April 14 at 11:40 P.M.

• **Lifeboat Capacity** — 1,178 persons

• **Sinking** — April 15 at 2:20 A.M.

• **Rescue Ship** — *Carpathia*

• **Survivors** — 706

# Chapter 8
# Nature Suffers

Advances in civilization can sometimes harm nature. Putting out a fire at a chemical factory accidentally poisoned half a million fish! An Australian farmer thought it would be fun to hunt a few rabbits — now they outnumber kangaroos in Australia by hundreds of millions, while the worst mistakes have occurred in the vulnerable Amazon. Learn how nature also suffers at the hands of some careless humans.

# Most Devastating Animal Introduction

Any animal imported into new territory can cause environmental damage. In 1859, Thomas Austin brought 24 wild rabbits from England and released them onto his property in southern Victoria, Australia. He only wanted more game for sport hunting. Seven years later, 14,253 rabbits were shot on Austin's estate alone. No natural predators meant a population explosion for the animal. By the year 1900, the **Most Devastating Animal Introduction** had overrun Australia (pictured). Today, there are more than 300 million rabbits — eating crops, destroying seedlings, and digging soil-damaging burrows. The rabbit infestation has destroyed numerous plant species and 12 percent of all native mammal species.

# Most Lethal Smog

On December 5, 1952, a unique weather inversion caused a high-pressure system to sit cold and windless over London, England. The city's smog became trapped too close to the ground. The smog was natural fog combining with the smoke generated by coal stoves burning in a million homes and factories. Londoners were accustomed to the "pea-soup" air; however, with visibility reduced to 12 inches, life came to a standstill for four days. Cinemas closed, cars were abandoned, airports shut, and children kept home out of fear of losing them in the thick, sulfurous yellow haze (pictured). The **Most Lethal Smog** caused more than 4,000 untimely respiratory deaths. New laws required a switch to clean-burning natural gas and launched the study of environmental health. Today's concern is that developing countries don't repeat London's not-so-long-ago tragedy.

## Rooted Facts

Some eye-opening facts about the world:

• One-fifth of Earth's total fresh water supply is in the Amazon rain forest.

• Forty percent of the world's remaining rain forest is in the Amazon. Other key forests are in Africa and Indonesia.

• Approximately 20 percent of the Amazon has already disappeared. Only 10 percent is under environmental protection.

• Two-thirds of the world's forests are already gone. The United Nations and World Bank are trying to protect 10 percent of Earth's remaining forests.

# Worst Destruction of the Natural Environment by Fire

The Amazon is 1.5 million square miles — that's about the same size as the 48 contiguous United States. This ecosystem is crucial to all life on Earth. Twenty percent of the planet's oxygen is created from this area, called by some "the world's lungs!"

The **Worst Destruction of the Natural Environment by Fire** came in 1997, when global arson raged throughout Brazil, Indonesia, North America, and Africa (pictured). More than 45,000 fires were deliberately set in the Amazon. Arson destroyed a shocking 93 percent of the forest along the heavily populated 1,000-mile-long Atlantic coast. Even virgin areas were irreversibly deforested in spite of the rain forest's moist and dense root systems.

# China's Great Green Wall

Rapidly developing China has the world's largest ecological program in place, in a nationwide effort to battle back the desert. Since an alarming 27 percent of the country is already desert, the "Great Green Wall" project has its work cut out for it. A belt of land covering 43 percent of China's total land mass is being reforested and revegetated. This immense effort has been recognized as the world's Largest Afforestation Project (pictured).

# Worst River Pollution

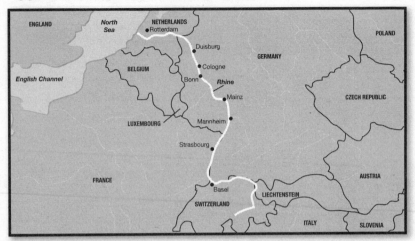

The 820-mile-long Rhine River (pictured) originates in Switzerland's pristine Alpine lakes to flow north through Austria, Liechtenstein, France, Germany, and the Netherlands, where it empties, into the North Sea. Years of neglect turned the Rhine into what some dubbed the "sewer of Europe." Countries argued over responsibility. A 1986 disaster changed people's attitudes. While extinguishing a fire at the Sandoz factory near Basel, Switzerland, water mixed with toxic pesticides flowed into the Rhine. The **Worst River Pollution** killed at least half a million fish, and sounded a drinking-water warning for 50 million people. Because the accident occurred soon after Chernobyl's disaster (see Record 21), serious efforts were begun to clean the Rhine. All countries agreed to cut noxious discharges, establish a river-wide alert system, and restore original flora and fauna. By 1996, salmon and sea trout, unseen for 50 years, swam upstream again!

# Worst Coastal Damage from an Environmental Disaster

The Exxon *Valdez* oil tanker ran aground on March 25, 1989, in Prince William Sound, Alaska, spilling 10.8 million gallons of oil (257,000 barrels) and polluting 1,500 miles of pristine coastline. The amount of oil could fill 125 Olympic-size swimming pools! At that time, no one knew how to respond to a spill of such magnitude. Many birds, fish, and sea animals died, largely because of oil on their fur or feathers — which led to hypothermia (dying of cold) — or from eating the oil itself. Although four years of intense cleanup followed, some shoreline remains polluted. The special color section shows the victims of the **Worst Coastal Damage from an Environmental Disaster**.

## Spill Stoppers

There were three days before the oil reached Alaska's shoreline when it could have been "skimmed" off the ocean. Today, all tankers are monitored and escorted in Prince William Sound. Experts are ready with equipment to contain a spill of up to 12 million gallons, with a recovery capability of 300,000 barrels of oil in under 72 hours. Additionally, all oil tankers in the sound are required to be double-hulled by the year 2015.

# Chapter 9
## Acts of War

Lions fight for their territory, and so do humans. The Chinese were fighting in 475 BCE — find out how long it took before someone actually said, "Cease fire!" World War II was shorter, yet its consequences were much longer-lasting. The effects of war upon people and nature are felt and seen in what is one of our most difficult chapters, because all of these disasters could have been prevented.

# Longest Continuous Period of Civil War

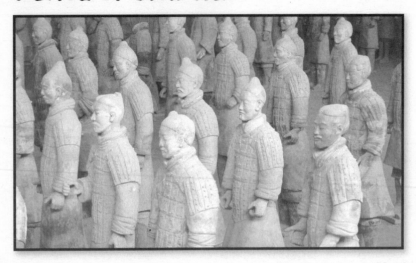

Records of Chinese history are astonishingly ancient. Until modern times, China was ruled by one dynasty after another. After the Zhou dynasty took control, the **Longest Continuous Period of Civil War** broke out — and went on for 254 years! The Warring States period (455–221 BCE) focused upon seven feudal warlords battling for supremacy. Iron replaced bronze as the dominant metal, and construction began on the Great Wall of China. In 230 BCE, the *Qin* (pronounced chin) state began conquest of the other states: Han, Wei, Chu, Yan, Zhao, and Qi. The unification of China was completed in 221 BCE with the Qi's defeat, and an age of peace began under the Qin Dynasty. Even in modern times, these terracotta warrior statues still stand guard over the tomb of Emperor Qin Shi Huangdi (pictured).

# Deadliest War

World War II began in 1939 with Germany's invasion of Poland and ended in 1945 with Germany's surrender and the detonation of atomic bombs in Japan. This was mankind's **Deadliest War**. Over 50 different nations aligned with either the Allied or Axis powers to fight battles primarily in Europe and the Pacific. Two percent of the world's entire population was lost — approximately 56.4 million people, half of whom were civilians. Many died from bombing, disease, or starvation. Millions were murdered out of racial hatred, particularly Jewish peoples, Gypsies, and other nationalities. This contrasted greatly with World War I, where less than 5 percent of casualties were civilians. At the end of WWII, the United Nations was founded in the hope of preventing another such disastrous global conflict from ever igniting again.

## Canines in Combat

War dogs have served alongside human soldiers since Roman times. Their superior sense of smell leads rescue platoons, identifies booby traps and poison gas, and tracks enemies. In WWII, "para pups" were dogs that parachuted behind enemy lines to aid their human counterparts in avoiding capture and carrying supplies (pictured).

# Greatest Ever Lifesaving Operation at Sea

Miracles do occur, even during the horrors of wartime. On May 8, 1942, the U.S.S. *Lexington* was torpedoed during the Battle of the Coral Sea at 11:20 A.M. The initial hits caused a number of deaths aboard the 888-foot-long aircraft carrier (pictured). Fires and other problems seemed to be under control, when a huge explosion occurred at 12:47 P.M. By 7:07 P.M., the Commander ordered all hands to abandon ship! Nearby ships responded to collect all 2,735 crewmen from the life rafts, making this event the **Greatest Ever Lifesaving Operation at Sea**.

# Worst Marine Oil Pollution

Saddam Hussein, the former leader of Iraq, invaded the neighboring country of Kuwait in August 1990. A coalition of 34 countries, led by the USA, went to war against Iraq in early 1991 to end Iraq's occupation of Kuwait. The Gulf War ended quickly, but Hussein ordered more than 600 Kuwaiti oil wells to be set on fire during his forces' retreat. A total 240 million gallons of oil were discharged — 20 times the amount of the Exxon *Valdez* spill (see Record 40). The gushing, burning wells took 9 months to cap. Land mines around the wells complicated the process. Unprecedented pollution marred the Arabian Gulf coastline. Smoke and soot traveled as far as the Himalayan Mountains. Oil lakes covered 25 percent of Kuwaiti desert. The region's land and wildlife are still recovering from this environmental terrorism, known as the **Worst Marine Oil Pollution** (pictured).

# Most People Killed in a Terrorist Attack

Direct attacks on American soil have been rare since the American Revolution. During WWII, the 1941 attack by the Japanese air force against the American military forces stationed at Pearl Harbor, Hawaii, resulted in the loss of 2,403 servicemen, 68 civilians, 188 aircraft, and 12 ships.

A different type of attack occurred on September 11, 2001, when terrorists hijacked and flew three jets into chosen targets: the two World Trade Center towers in New York City (pictured); and The Pentagon, headquarters of the U.S. Department of Defense, in Virginia, near Washington, D.C. A fourth plane went down in Pennsylvania without striking its target. A total loss of 2,985 people, including 343 firefighters and 60 police rescue workers, marked this event as the **Most People Killed in a Terrorist Attack**. Many people worldwide are working together to stop this kind of catastrophe from ever happening again.

# A Tale of Two Towers

The World Trade Center's twin towers were designed by architect Minoru Yamasaki and built in 1972-1973 (see the special color insert). Tower One was 1,368 feet high. Tower Two was slightly shorter at 1,362 feet. Each building featured 110 stories. On a typical day, approximately 50,000 people worked in the twin towers and another 200,000 visitors passed through. The towers, plus their sister buildings nearby, formed a large enough area to qualify for its own zip code: 10048. The twin towers were the tallest buildings in the world until 1974. At that time, the Sears Tower in Chicago, Illinois, took the title at 1,450 feet. Since then, international competitors continue to build sky-scraping structures to become the Tallest Building in the World.

# Chapter 10
## Rising to the Challenge

Disasters are tragic events, whether the causes are natural or manmade. Yet even in the darkest hour, hope shines from people actively caring about each other. The world becomes a better place when people work together. Here are a few individuals whose special spark motivated others and inspire us!

# Youngest Nobel Peace Prize Laureate

Do you have some ideas on how to create peace throughout the world? The annually awarded, world-renowned Nobel Prize marks achievement in five arenas: physics, chemistry, physiology or medicine, literature, and peace. The prize for peace, first given in 1901, is awarded to the person who does the most or the best work for brotherhood between nations, for the abolition or reduction of armies, and for the holding of peace meetings. The record-holder for **Youngest Nobel Peace Prize Laureate** is Mairead Corrigan from Northern Ireland (pictured). She was 32 years old in 1976 when she and co-winner Betty Williams started a door-to-door citizen's movement against the violence around them, which was caused by ongoing internal religious and political strife in Northern Ireland.

# Peaceful King

America's youngest Nobel Peace Prize laureate was Martin Luther King, Jr., who was awarded this honor in 1964 at the age of 35. Dr. King believed in and advocated non-violent methods to end racism and apartheid globally. His ideas, eloquent speeches, and determination to improve others' lives lasted beyond his death. Social changes in the USA and abroad can be traced back to Dr. King's goal of transforming his dream of equality for people of all races and nations into a reality.

# Largest Food Drive by a Non-Charitable Organization

You *can* make a difference! At San Mateo High School in California, USA, students have been making a difference for 18 years — by collecting canned food for the Samaritan House, a charity that provides food, shelter, and medical help to thousands of people in the San Francisco Bay area each year. The students are motivated, organized, and actively involved in improving others' lives. Each year, the food drive takes place during the last two weeks before winter break.

The school's first Guinness World Record came when 1,400 students collected 214,713 pounds of food between December 3 and 17, 1999. Then the school broke its own record with the 2004 drive, raising 337,141 pounds for the **Largest Food Drive by a Non-Charitable Organization**!

Interested in doing a food drive (pictured)? Work with your local organization to form teams, write letters, and pledge for dona-tions. Even if you don't break a record, you will change someone's life for the better.

# Largest and Longest-Running Humanitarian Airdrop

The **Largest Humanitarian Agency** is the UN World Food Program (WFP) and among its many life-saving operations is its daily support of Sudan's people. Since 1992, the WFP has been operating the world's **Largest and Longest-Running Humanitarian Airdrop** in southern Sudan (pictured). The operation's goal is to prevent 2.5 million people from starving because of drought, civil war, flooding, and remote living conditions. At its peak, the WFP managed three trips by 14 aircraft delivering an average of 352,000 pounds of food — every single day!

# Largest Volunteer Ambulance Organization

It's amazing what you can do by just getting started. In 1947, Abdul Sattar Edhi bought an old van and started a free ambulance service for the poor in a neglected area of Karachi, Pakistan. One vehicle with one volunteer led to a fleet of ambulances and thousands of helping hands (pictured). Today, Edhi and his wife, Bilquis, plus volunteers and private donations, make a BIG difference throughout Pakistan. The **Largest Volunteer Ambulance Organization** has more than 500 ambulances, including air ambulances; 300 medical centers and hospitals; and several homes for the homeless, handicapped, orphans, and mothers-to-be.

## Med School, Too!

Why is Edhi's work so important? Pakistan is an economically underdeveloped country, but its current population is 150 million, half of whom are under 15 years old. By the year 2035, the population could double to 300 million (that's similar to the USA!). Understanding that many poor people are also uneducated, Edhi established literacy training for nurses, pharmacists, and other medical professionals. To date, 40,000 nurses have been trained, with more than a million babies safely delivered. Edhi's dream is to see Pakistan become a modern state with basic health, education, and social rights.

# Largest United Nations Emergency Appeal

Other people, from friends to strangers, can help the survivors cope with physical cleanup and emotional recovery after a disaster has struck (pictured). Once the worldwide news reported the wide spread devastation caused by the 2004 tsunami, people rose to the challenge of sending assistance to those in need (see sidebar). The **Largest United Nations Emergency Appeal** provided $977 million to five million people in Southeast Asia, the Seychelles, Sri Lanka, and Somalia. This event marked the largest appeal ever launched for relief assistance in the aftermath of a natural disaster. The monies sent will rebuild houses, schools, hospitals, and most importantly, people's lives. Visit the special color section to see how nature lent a helping hand in the recovery efforts.

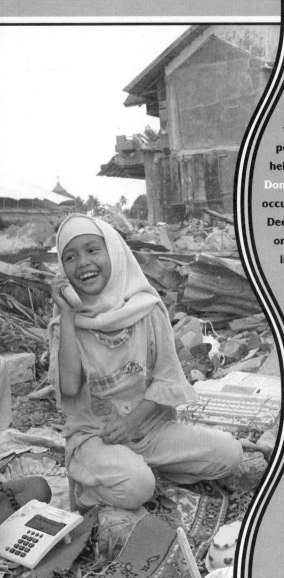

# Online Help

Click and send is the fastest delivery system throughout the world today. So when the news reported the tsunami's devastation, people got online to help. The Most Money Ever Donated Online in 24 Hours occurred from 6:16 P.M. on December 30 until 6:16 P.M. on December 31, 2004. Based in the UK, the Disasters Emergency Committee Tsunami Earthquake Appeal (DEC) received a heartwarming 166,936 donations from the UK public. This amounted to a total of $645 million sent by more than two million donors.

# BE A
# Record-Breaker!

*Message from the Keeper of the Records:*
Record-breakers are the ultimate in one way
or another — the youngest, the oldest, the
tallest, the smallest. So how do you get to be a
record-breaker? Follow these important steps:

**1.** Before you attempt your record, check
with us to make sure your record is suitable
and safe. Get your parents' permission. Next,
contact one of our officials by using the record
application form at *www.guinnessworldrecords.com*.

**2.** Tell us about your idea. Give us as much
information as you can, including what the record is,
when you want to attempt it, where you'll be doing it,
and other relevant information.

> **a)** We will tell you if a record already exists,
> what safety guidelines you must follow during
> your attempt to break that record, and what
> evidence we need as proof that you completed
> your attempt.

**b)** If your idea is a brand-new record nobody has set yet, we need to make sure it meets our requirements. If it does, then we'll write official rules and safety guidelines specific to that record idea and make sure all attempts are made in the same way.

**3.** Whether it is a new or existing record, we will send you the guidelines for your selected record. Once you receive these, you can make your attempt at any time. You do not need a Guinness World Record official at your attempt. But you do need to gather evidence. Find out more about the kind of evidence we need to see by visiting our Web site.

**4.** Think you've already set or broken a record? Put all of your evidence as specified by the guidelines in an envelope and mail it to us at Guinness World Records.

**5.** Our officials will investigate your claim fully — a process that can take a few weeks, depending on the number of claims we've received and how complex your record is.

**6.** If you're successful, you will receive an official certificate that says you are now a Guinness World Record-holder!

Need more info? Check out the Kids' Zone on *www. guinnessworldrecords.com* for lots more hints and tips and some top record ideas that you can try at home or at school. Good luck!

# Photo Credits

The publisher would like to thank the following for their kind permission to use their photographs in this book:

5 Volcanic Eruption Cristoph/Morguefile; 7 Tsunami © Punit Paranjpe/Reuters/ CORBIS; 9 Krakatoa Eruption Illustration © David Hardy/Photo Researchers, Inc.; 10 Tambora © CNES 2002; 11 Mount St. Helens © Gary Braasch/CORBIS; 12 Japan Earthquake, 18 Thailand Monsoon © Hulton-Deutsch Collection/CORBIS; 15 Tornado © Fort Morgan Times/AP Wide World Photos; 16 Tornado Survivors, 64 Rabbits, 73 War Dogs, 81 Martin Luther King © Bettmann/CORBIS; 17 Hurricane Mitch Survivors © Bisson Bernard/CORBIS SYGMA; 19 Drought Victim, 41 Chernobyl © Reuters/CORBIS; 20 Geomagnetic Storm Illustration © NASA; 21 Lake Nyos © Peter Turnley/CORBIS; 23 Icicles © Uli Wiesmeier/zefa/CORBIS; 24 San Francisco Fire © A.L. Murat/CORBIS; 26 Avalanche Survivors © Hulton Archive/Getty Images; 27 St. Bernard Rescue Dog © H. Reinhard/zefa/CORBIS; 28 Snow Storm, 49 New Delhi Plane Wreckage, 53 MIR Crew, 57 Beck Weathers © AP/Wide World Photos; 29 Ice Storm © Syracuse Newspapers/AP Wide World Photos; 31 Germs © LSHTM/Photo Researchers, Inc.; 32 Pandemic © Mary Evans Picture Library; 33 Rat © Photodisc via SODA; 34 Mosquito © Darlyne A. Murawski/Peter Arnold, Inc.; 35 Influenza Epidemic Article © Granger Collection; 36 CDC © Shepard Sherbell/CORBIS SABA; 39 Cityscape © Royalty-Free/CORBIS; 42 Bagmati River Train Wreckage © PTI/AP Wide World Photos; 43 (top) Baku Mourners © AFP/Getty Images; 43 (bottom) Locomotive, 55 Mountains © istockphoto; 44 Sultana © Library of Congress; 45 Chunnel Map © MAPS.com/CORBIS; 47 Clouds © Corbis; 48 Plane Crash Memorial Service © Yomiuri Shimbun/AP Wide World Photos; 51 Concorde Flight 4590 © Toshihiko Sato/AP Wide World Photos; 52 Baikonur Cosmodrome © Mikhail Metzel/AP Wide World Photos; 56 Burn Victim © Annie Griffiths Belt/ CORBIS; 58 Feline Survivor © Reuters; 59 Vesna Vulovic © Libor Zavoral/AFP/ Newscom; 60 Millvina Dean © Ian Cook/Time & Life Pictures/Getty Images; 63 Amazon © Mary Thorman/Morguefile; 65 London Smog, 74 U.S.S. Lexington © Keystone/Getty Images; 67 (top) Brazil Fire © H. John Maier Jr./Image Works/ Time Life Pictures/Getty Images, (bottom, left) Amazon Fire © Joanna B. Pinneo/ Getty Images, (bottom, right) Great Green Wall © Li Gang/Xinhua Photo/CORBIS; 71 Soldiers © Regis Bossu/Sygma/CORBIS; 72 Terracotta Warriors © Lee White/ CORBIS; 75 Kuwait Oil Fields Ablaze © Nicholas Kamm/AFP/Getty Images; 76 9/11 NYC Firefighters © Mark Lennihan/AP Wide World Photos; 79 Sunrays © James M. Sawyer/Morguefile; 80 Mairead Corrigan © Leif Skoogfors/CORBIS; 82 Food Drive © Dave Scherbenco, Photo/Citizens' Voice/AP Wide World Photos; 84 WFP Airdrop © Edward Parsons/AFP/Getty Images; 85 Pakistani Volunteer Ambulance Service © Mohammad Ali/AP Wide World Photos; 86 Tsunami Survivors © Tarmizy Harva/ Reuters/CORBIS.